IMAGES
of America

SACRAMENTO'S
LAND PARK

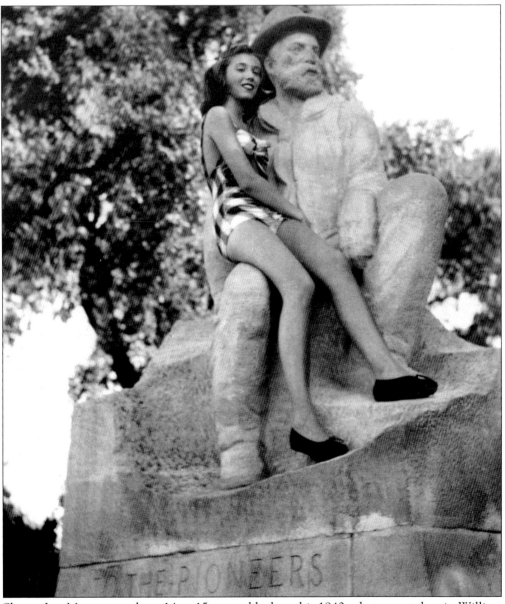

Sharon Lee Maxon was about 14 or 15 years old when this 1940s photo was taken in William Land Park. Maxon is sitting on the lap of a statue of pioneer Charles Swanston. (Courtesy of Cindy Anderson.)

IMAGES
of America

SACRAMENTO'S LAND PARK

Jocelyn Munroe Isidro

ARCADIA

Copyright © 2005 by Jocelyn Munroe Isidro
ISBN 0-7385-2965-6

Published by Arcadia Publishing
Charleston SC, Chicago IL, Portsmouth NH, San Francisco CA

Printed in the United States of America

Library of Congress Catalog Card Number: 2004116366

For all general information contact Arcadia Publishing at:
Telephone 843-853-2070
Fax 843-853-0044
E-mail sales@arcadiapublishing.com
For customer service and orders:
Toll-Free 1-888-313-2665

Visit us on the Internet at www.arcadiapublishing.com

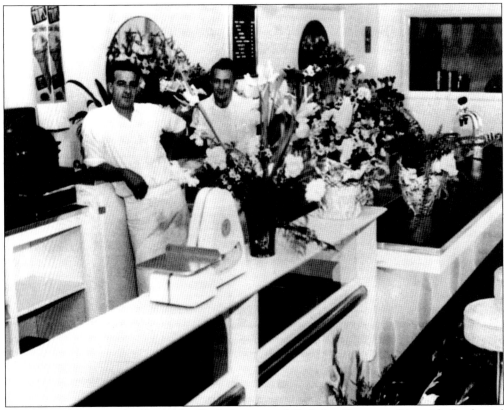

Vic Zito and his army buddy Ashley Rutledge opened Vic's Ice Cream on Riverside Boulevard in 1947 after World War II. Although Vic passed away in the 1960s, the popular family business continues on. Ash Rutledge's son Craig runs the store these days, and they still make their own ice cream. (Courtesy of Vic's Ice Cream.)

CONTENTS

ACKNOWLEDGMENTS

This book would not have been possible without the knowledgeable, dedicated, and generous assistance of two outstanding local research facilities: the Sacramento Archives and Museum Collections Center (SAMCC) and the Sacramento Room of the Sacramento Public Library. In addition, I am most grateful to the individuals listed here who gave so freely of their photos, memories, and time to help complete this project: John Kessler, Gladys Parkhurst, Jim Kessler, Joe Genshlea, John Hamlyn, Alan O'Connor, Joe Lyons, Margaret Lyons, Cindy Anderson, Julie DiLoreto, Russ Solomon, Jim Henley, Pat Johnson, Dylan McDonald, Kevin Morse, Sally Stephenson, George White, Ashley Rutledge, Craig Rutledge, Tom Tolley, Julie Thomas, Julie Gianulias, Gus Gianulias, Chris Gianulias, Andy Gianulias, Angela Gianulias, Janet Bollinger, Janice Scott, Kurt Rusk, Eugene Itogawa, Debbie Gordon, Dagmar Smith, Donna Vann, Zonia Wasser, Dorothy Mills, William Mahan, Father Brady, Jane Dolcini, Penelope Payne, Derek Rudnak, Carrie Cornwell, Estelle Opper, Gillian Parillo, William Shubb, Claire Ellis, Walt Wiley, Kathy Adams, Teresa Allen, Sue Olson, and the Nakatani family.

INTRODUCTION

Sacramento's leafy and elegant Land Park neighborhood has a rich history. Originally, the area was part of John Sutter's Mexican land grant known as New Helvetia. As John Sutter's fort grew, even before gold was discovered, he wanted to build a town on high, flood-proof lands in what is now the southern Land Park area. He hired an engineer to map out a town named Sutterville, about three miles south of the current city of Sacramento, roughly where Sutterville Road and Riverside now meet. Nearby the important Sacramento River, Sutterville actually trumped the tiny upriver port of Sacramento for several years. A hotel and several saloons were built on the streets of Sutterville, and a ship's carpenter, doctor, brewery owner, and brick maker all ran businesses there, among others.

Gold-rush chasers, Native Americans, saloonkeepers, farmers, soldiers, and cattle ranchers all mingled in the dusty streets of Sutterville from the 1840s to the 1900s. Gunshots often rang out in saloons as a lusty frontier life played out. In the 1860s, a Civil War military base, Camp Union, was located at the site of the current Sacramento Zoo. Strict military justice, including hanging, was often exacted upon criminal soldiers.

But the Marshall gold discovery and situations involving Sutter's inept money handling reset the focus of development toward Sacramento, and Sutterville never fulfilled its promise. By 1952, the last remnant of the old town, the Sutterville Brewery, was demolished.

The southern area, although mostly barren and swampy, was still appreciated by pioneer ranchers, hop growers, dairymen, and adventurous homesteaders, who enjoyed the proximity to the city and the river, and delighted in the area's large tracts of land. Most of the population was settled around Riverside Road, and Sacramento eventually annexed this area. Others lived along Freeport Road or Sutterville. The Swanston family raised cattle along the Riverside Road; the Cavanaugh family grew hops and raised thoroughbred racehorses off of Sutterville Road; John Kessler and his family ran the riverside Union Dairy from the end of Swanston Drive; and C.V. Brockway's Freeport Road ranch had a spectacular driveway encircling a fountain in front of his Victorian farmhouse. Many Japanese and Chinese truck farmers provided downtown Sacramento residents with fresh fruits and vegetables from the area.

Despite these savvy settlers, the Land Park area used to have a less-than-savory, even "odorous" reputation. For years, the City of Sacramento disposed of its raw sewage across its city

line at Y Street via a series of drainage ditches and sloughs. Adding to the region's lack of appeal were three cemeteries, including Sacramento's old city cemetery, with thousands of interred residents.

All land south of Y Street was considered the flood spill for Sacramento. When flooding occurred, levees were opened, such as one at the foot of today's Sutterville Road called the Edwards break, to save Sacramento city proper. South area residents had to drive for miles around their inundated lands just to get downtown. The City didn't seem too concerned about farmers' flooded fields, however. The *Sacramento Bee* reassured its readers with this headline from 1904: "Inundated Area South and Southeast of City Will Drain Speedily After Closing of Break," adding, "Grain and Vegetables planted in Submerged District Will Have to Be Resown, But It Is Not Believed Hops Will Suffer. Cemeteries Partly Submerged and Unusual Scenes Presented." Apparently the Bee knew what their readership really cared about—beer! And one can only imagine the unusual scenes observed in the flooded cemeteries.

Then there were the unregulated bars, saloons, and speakeasies that blossomed in the southern neighborhoods. A "whisper campaign" during local brewery wars contended that the old Sutterville Brewery used slough water for their ale, not to mention the brewery worker who drowned in a vat and got brewed into beer. The Bush Quinn speakeasy at the corner of Sutterville and Riverside was a notorious roadhouse that reportedly served liquor to minors and girls, thereby almost killing Land Park before it was even developed.

The *Sacramento Bee* ran several scathing editorials against both the Bush Quinn roadhouse and the unpopular idea of using the money left to the City by hotelier and mayor William Land for a park in the southern Riverside district. In a 1916 editorial, the Bee stated that the Riverside site was a poor one because it was nothing but "swamp and hardpan. You could never grow grass there, let alone a tree."

City residents, including even those in the Riverside district (only a few of whom bothered to vote), elected to put the park in Del Paso, rather than on the land that cattleman Charles Swanston and associates had put up for the purpose.

But eventually, after a bitter, years-long court fight that reversed the public election, William Land Park was placed squarely in the unpopular district in the 1920s, and suddenly the area's stigma was gone. From the 1920s to the 1940s, expensive homes were built along wide curving streets surrounding the new park. A wonderful old marketing brochure for new home plots describes the area as "a perfect environment outside in sunshine and fresh air—where a spacious golf course lies at your door; where you can enjoy complete rest and peace of mind; where you can raise your children in happy, healthful surroundings." Of course it didn't mention that only whites were welcome to buy.

The area grew slowly but steadily until just around World War II, when the demand for housing converted hop fields to housing tracts. Neighborhoods such as College Tract, Swanston Tract, and Sutterville Heights sprouted from raw fields.

Many of Sacramento's prominent citizens settled in the lovely neighborhoods around the park, drawn by their proximity to the city and the quiet, rural setting, just as their predecessors were decades earlier. Land Park has been home to Supreme Court Justice Anthony Kennedy, who graduated from McClatchy High; author Joan Didion, another McClatchy grad; the late U.S. senator Robert Matsui; and numerous politicians; business owners; and even painter Thomas Kincade, who says his early childhood amidst Land Park's fanciful architecture was a major influence on his art.

Although our neighborhood is no longer someplace from which you can see all the way to the capitol from your front porch, it has a timeless quality to it that people respond to and cherish.

Joan Didion said it best: "A place belongs forever to whoever claims it hardest, remembers it most obsessively, wrenches it from itself, shapes it, renders it, loves it so radically that he remakes it in his own image."

It's no longer swamp and hardpan, and trees most definitely grow here. Land Park is truly a land apart.

One

EARLY HISTORY

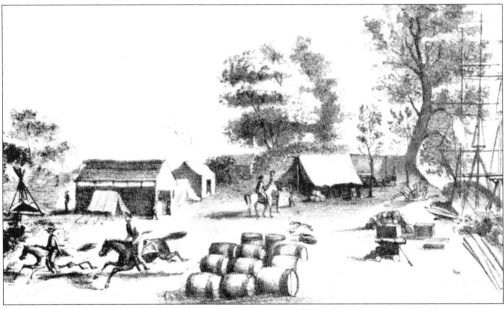

The town of Sutterville began with John Sutter's attempt to relocate the population center around his fort, from the flood plain to sensible high ground three miles south of today's Sacramento city center, to what is now about the site of Sutterville and Riverside Boulevard. This 1846 sketch shows an active and burgeoning riverside village, which by 1847 had a large brickyard, a ships' carpenter, a blacksmith, and many saloons. J.M. Letts, a shareholder in a New York mining company who came to California in 1949, described a family he had met in Sutterville, who "had been wandering about since 1845, without having entered a house . . . The children were all natives of the forest except the eldest. They were encamped under a large oak-tree a short distance from the river. The bed was made up on the ground, the sheets of snowy whiteness, the kitchen furniture was well arranged against the root of the tree, the children were building a playhouse of sticks, while the mother was sitting in a 'Boston rocker' reading the Bible, with a Methodist hymn-book in her lap." (Courtesy of Special Collections of the Sacramento Public Library.)

INDIAN SPEARING SALMON.

The first inhabitants of the area we know as Land Park and South Land Park were a small tribe of Southern Maidu Indians known as Nisenan, or Sama. Their village was situated near today's Seamas Avenue. Many other indigenous tribes likely passed through the land over the years. They lived off the bountiful river and fertile lands around it, on grounds high enough to provide refuge from winter flooding. (Courtesy of Sacramento Archives and Museum Collection Center.)

California Indian Squaw and Children.

Indian scholar Dr. Alfred Kroeber estimates that there were 9,000 or less Maidu in 1770. The 1910 census returned 1,100, and the 1930 census turned up only 93. (Courtesy of SAMCC.)

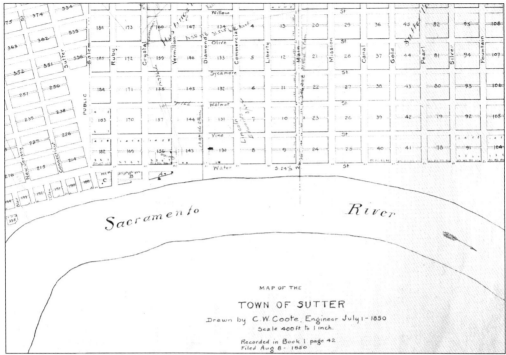

In 1850, at the request of John Sutter, engineer C.W. Coote drew up this plan for the town of Sutter, or Sutterville. Despite its sensible, above-the-floods location, the city formed in Sacramento, not Sutterville. Faint lines on the map show the streets that actually came into being, but most of the streets on this map were never developed. Although the map does not show it, there was a large, shallow lake between the river and the town of Sutterville. Sutter had Coote lay out land plots directly in the lake, which he planned to have filled in later. (Courtesy of SAMCC.)

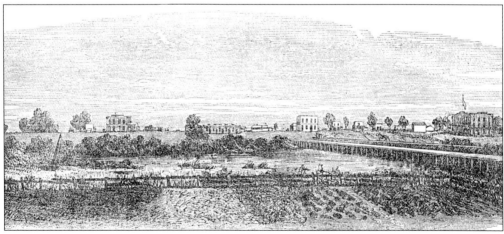

This 1850s sketch of Sutterville, as seen from across the Sacramento River in Yolo County, shows the lake that was between the river and the town of Sutterville and was later filled in. The white building just right of center is probably the old Sutterville Brewery. (Courtesy of Special Collections of the Sacramento Public Library.)

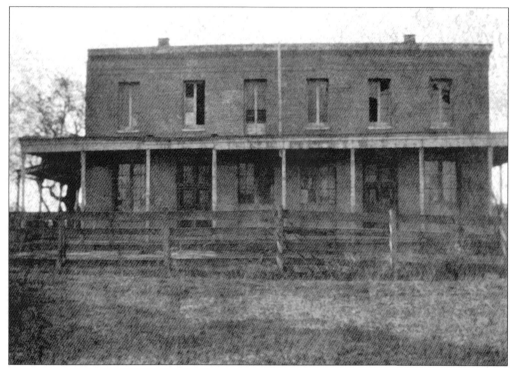

The old Sutterville Brewery was built around 1853 in John Sutter's original town of Sutterville, and was located just south of the current zoo grounds on Sutterville Road. Over the years it was a brewery, dance hall, store, and private residence. Demolished in 1952, the brewery was the last building from the old town of Sutterville. (Courtesy of SAMCC.)

This photo shows the Sutterville Brewery on Sutterville Road in the early 1950s, just before it was demolished. (Courtesy of SAMCC.)

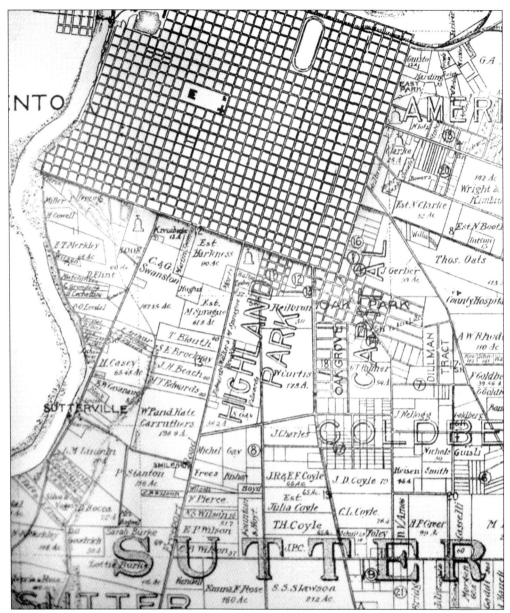

In this city map from 1903, Sutterville is still recognizable although only remnants of the town remained. Visible are the Swanston, Caruthers, and Cavanaugh ranches plotted out between Riverside and Freeport Roads. The faint line that snakes between the ranches was one of the drainage sloughs that Sacramento City proper used to get rid of their raw sewage. (Courtesy of Special Collections of the Sacramento Public Library.)

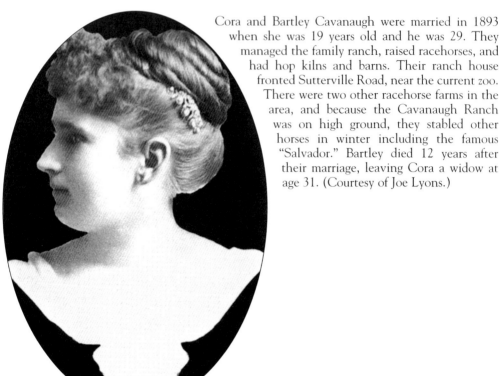

Cora and Bartley Cavanaugh were married in 1893 when she was 19 years old and he was 29. They managed the family ranch, raised racehorses, and had hop kilns and barns. Their ranch house fronted Sutterville Road, near the current zoo. There were two other racehorse farms in the area, and because the Cavanaugh Ranch was on high ground, they stabled other horses in winter including the famous "Salvador." Bartley died 12 years after their marriage, leaving Cora a widow at age 31. (Courtesy of Joe Lyons.)

The elder Bartley W. Cavanaugh came from Ireland to America as a cabin boy on a sailing ship when he was 11 or 12. He settled first in Boston and then in California. This is a photo of his son, also named Bartley W. Cavanaugh, who was a rancher on the present site of William Land Park, near the current zoo. This Cavanaugh was a bookmaker, hops merchant, racehorse breeder, and a Sacramento political boss. His grandson, also named Bartley W. Cavanaugh, was Sacramento's city manager from 1846 to 1964. (Courtesy of Joe Lyons.)

14

A Civil War military camp, Camp Union was roughly located at what is now the entrance to the Sacramento Zoo. The baseball fields north of the zoo used to be called the parade grounds, perhaps because of the camp. Soldiers from Camp Union assisted Sacramento residents during the 1862 floods, protected mail runs, fought Indians, and protected the southwestern United States. They were also known to frequent the nearby Sutterville Brewery and to pilfer chickens from the brewery's flock. (Courtesy of SAMCC.)

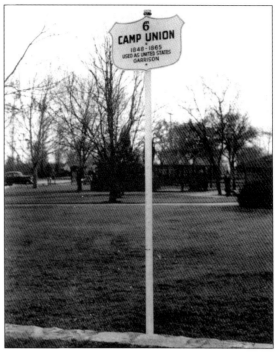

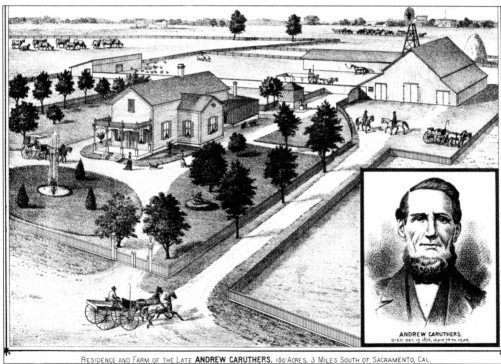

RESIDENCE AND FARM OF THE LATE **ANDREW CARUTHERS.** 160 ACRES, 3 MILES SOUTH OF SACRAMENTO, CAL.

Andrew Caruthers was a pioneer from Pennsylvania who moved to Sacramento in 1849. He had this ranch on over 160 acres on the site of what is now the southeast corner of William Land Park (Freeport Boulevard and Sutterville Road). (Courtesy of Thompson & West's *History of Sacramento County, California*.)

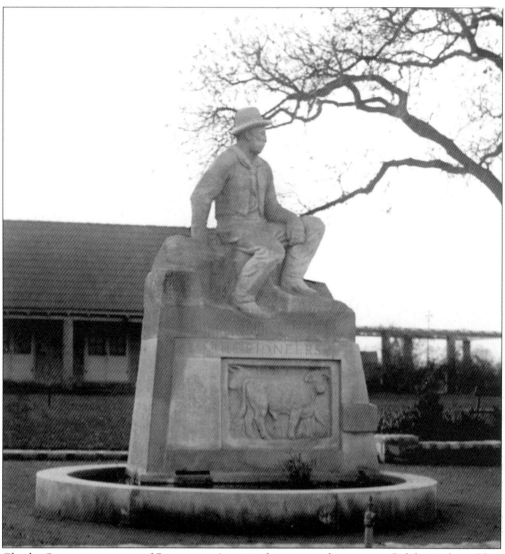

Charles Swanston was one of Sacramento's original pioneers who came to California from Ohio in 1881. He raised cattle off Riverside Boulevard and founded C. Swanston and Son Meat Packing Company there in 1886. His son George erected this Land Park statue in his memory. The building in the back was once the park pavilion, also known as the dance pavilion, and today this area is part of the Sacramento Zoo. (Courtesy of SAMCC.)

George Swanston, son of pioneer Charles Swanston, came with his family to Sacramento at age 15. He worked with his father in the family livestock business and took over the family meatpacking operations (originally located on Riverside Boulevard) when his father died. George Swanston was instrumental in promoting the southern Sacramento area as the home for William Land Park. He built a magnificent mansion at the end of Swanston Drive. The original palms that lined the road to the house can still be seen on Swanston Drive. (Courtesy of McClatchy High Library.)

Jennie Ward Swanston was born in Eldorado, California. Her pioneering father came to California from England across the Isthmus of Panama at age 17; and her mother, also a pioneer, came with her parents across the plains at age 8. Jennie Ward and George Swanston married in 1888 and had two children, Lillis and Robert. (Courtesy of McClatchy High Library.)

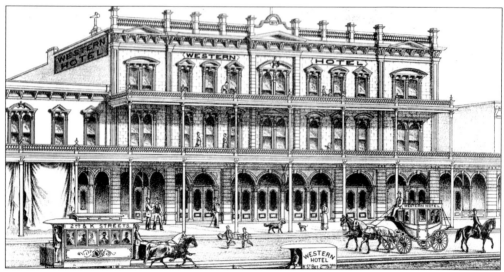

William Land made his fortune with the Western Hotel, which was located in downtown Sacramento at K and Second Streets. The Western was world famous due to Land's brilliant and competitive marketing. A room was $1 to $2 a night, and meals at the meal counter were 25¢. Land personally collected the money with his white bulldog by his side. According to a friend of Land, "business in those days was secured largely by 'runners' who solicited at stage stations, steamer landings and railroad depots. In this rude and hard competition, Land excelled and no bully, ruffian or gun fighter ever intimidated him. He filled his busses and he filled his hotel." (Courtesy of Thompson & West's *History of Sacramento County, California*.)

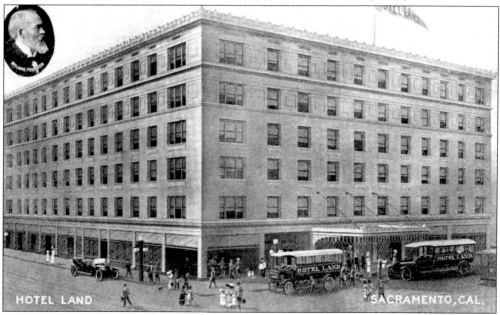

Land later opened the Hotel Land in downtown Sacramento and continued his success. He became mayor of Sacramento for one term (1898–1899), and was a committed philanthropist. When he died in December 1911, he left, among other legacies, "$250,000 to purchase a public park within a suitable distance" of Sacramento to be used as "a recreation spot for the children and a pleasure ground for the poor." (Courtesy of the author.)

Two
RIVERSIDE DISTRICT

This 1890 cyanotype has a handwritten caption that reads: "The long forgotten 'Riverside Road.' The speedway for our fine carriages." This seems to indicate that Riverside Road was used for carriage races at one time. The popular Riverside Resort and picnic grounds south of Sutterville may have been the cyclist's destination. Riverside Road was a toll road in the past, and the toll office was on Riverside near Y Street (Broadway). (Courtesy of SAMCC.)

This 1910 photo shows the house at 3300 Riverside Boulevard, which is still there today.
(Courtesy of SAMCC.)

The Saccani family came to Sacramento from Pennsylvania in 1922. They stayed at the notorious Bush Quinn speakeasy and hotel for several months then rented a house on Riverside Boulevard. Later, patriarch Domenico Saccani built this house at 840 Ninth Avenue. Pictured in the 1930s outside the house with his new auto is Domenico's son Enio. (Courtesy of Gary Saccani.)

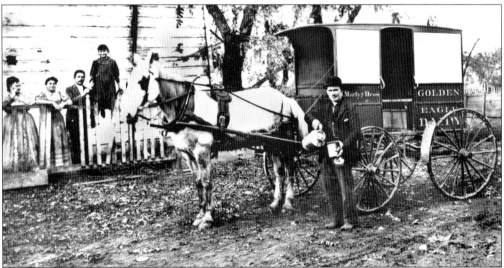

Tony Marty owned the Golden Eagle Dairy, which was once located where Land Park Drive is today. This photo is most likely from the 1880s. Tony Marty is standing behind the fence. (Courtesy of SAMCC.)

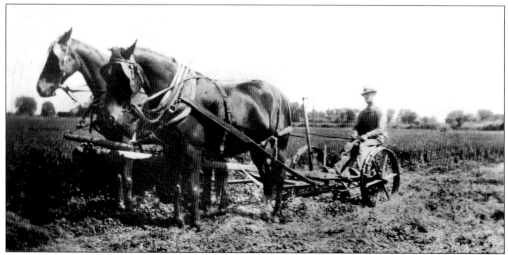

John Kessler emigrated from Switzerland in 1893 to avoid mandatory military service and a career in lace making. He settled first in the Midwest and later in the West. He bought the Union Dairy from a farmer near McKinley Park, and moved it in 1909 to the end of Swanston Drive. This 1914 photo shows John with his plow near the dairy. (Courtesy of the Kessler family.)

In 1920, John Kessler delivered milk in tall cans from the back of a truck. His route included what is now Old Sac but was then skid row, between Second and J Streets. His son Geb made deliveries with him and recalls transients asking, "Hey Mr. Milkman, can I have a drink of milk?" John would ask to see their hands, and if they looked like they had been working, he'd give them a drink. (Courtesy of the Kessler family.)

The Union Dairy was a well-maintained place. Every part of the milk-producing operation had to be kept scrupulously clean and sanitary. This photo was taken in 1929. (Courtesy of the Kessler family.)

Gebhardt Kessler always got up early to deliver milk. It was a short distance from the dairy to the Sacramento River. One morning, Geb caught this great blue heron on the dairy grounds, and he had his mother snap the picture before he let the bird free. (Courtesy of the Kessler family.)

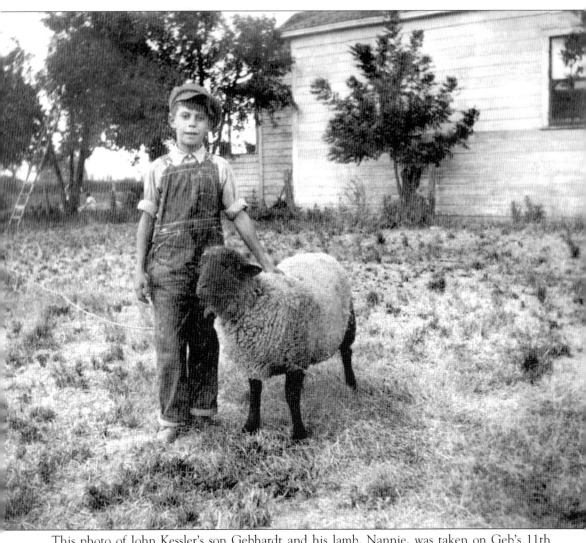

This photo of John Kessler's son Gebhardt and his lamb, Nannie, was taken on Geb's 11th birthday in 1922. A note on the photo reads that Nannie was 7 months and 8 days old. (Courtesy of the Kessler family.)

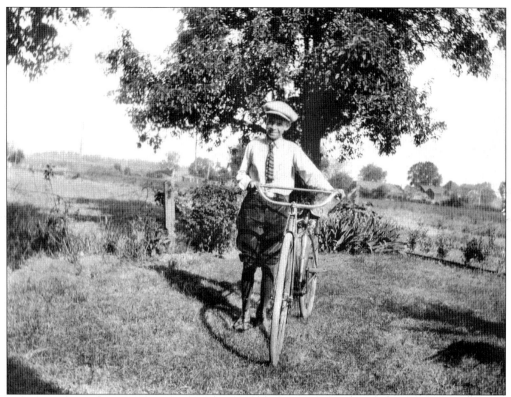

Gebhardt Kessler is shown here with his bike in 1924. The area around Riverside Boulevard was mostly rural. Geb's father John rented some of his land to Japanese vegetable farmers. When he wanted to buy something special, like wingtip shoes, Geb grew corn and sold it door-to-door. (Courtesy of the Kessler family.)

Gebhardt Kessler inscribed this photo: "Gebhardt Kessler, age 18 and a big punk, my sweetheart Esther Gorton." The words "big punk" were later crossed out . . . perhaps by Esther. (Courtesy of the Kessler family.)

Pictured in 1930 are Gebhardt Kessler and his uncle Hank, on one of the older Union Dairy delivery trucks. (Courtesy of the Kessler family.)

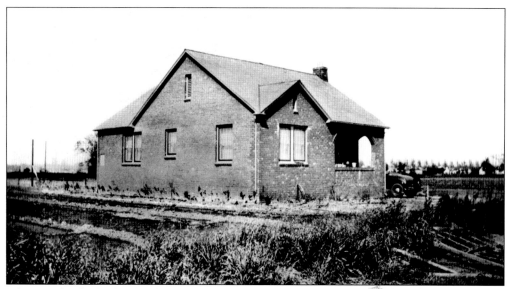

John Kessler built this brick house on Swanston Drive in 1932. His family moved in on Valentine's Day, 1933. For years it was the only house on the west end of Swanston. (Courtesy of the Kessler family.)

Gebhardt Kessler is shown here with his children at the Swanston Drive brick house in 1939. His oldest daughter Gladys was 6, son Jim was 3, and daughter Virginia was 3 months old. The youngest son John was not yet born. (Courtesy of the Kessler family.)

Geb's son John Kessler was the third generation of Kesslers to live in the brick house on Swanston Drive. (Courtesy of the Kessler family.)

Over 70 years after it was built, the brick home on Swanston Drive looks about the same but now has many neighbors, and the trees have grown. (Courtesy of the author.)

This photo shows Swanston Drive looking east, after sidewalks were added. The Kessler's brick home was behind the hedge on the left. (Courtesy of the Kessler family.)

In this 1944 photo, Jim Kessler stands at attention on Fourth Avenue. (Courtesy of the Kessler family.)

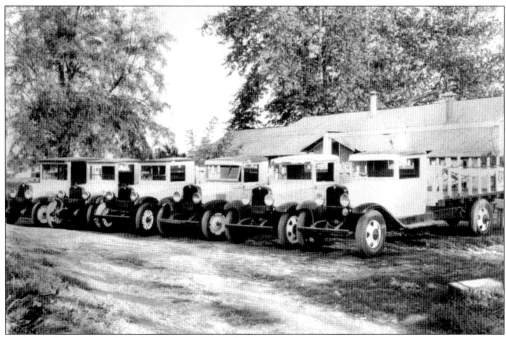

A sleek fleet of trucks is lined up at the Union Dairy, ready to deliver milk to Sacramento. (Courtesy of the Kessler family.)

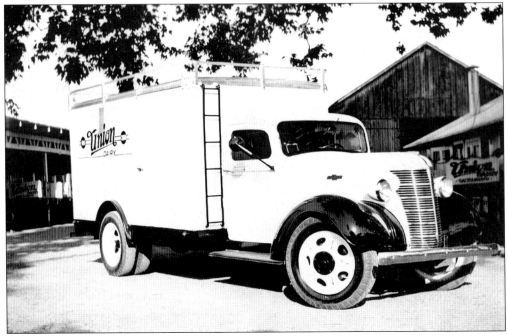

By 1929, Union Dairy was delivering its milk with modern trucks. (Courtesy of the Kessler family.)

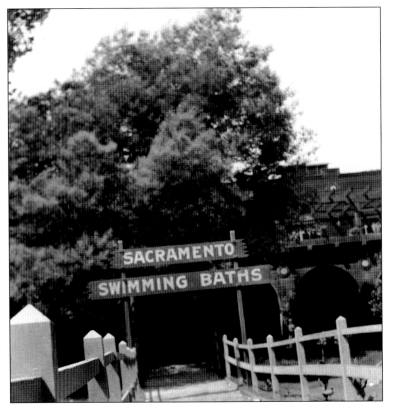

This 1919 photo shows the Sacramento Swimming Baths, also known as the Riverside Baths, City Baths, and later Land Park Plunge. The popular destination had its own railroad stop called the Baths. In addition to its large swimming pool, the Baths also had a room set aside with bathtubs where city residents without facilities could bathe. (Courtesy of SAMCC.)

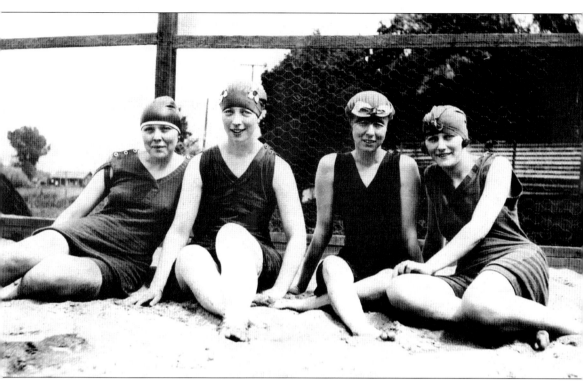

In this *c.* 1912 photo, Martha Mae Straumann and her friends enjoy the Riverside Baths. The girls are about 14 years old, according to Straumann's granddaughter Cindy Anderson. During wartime internment, Japanese were prohibited from entering the baths. (Courtesy Cindy Anderson.)

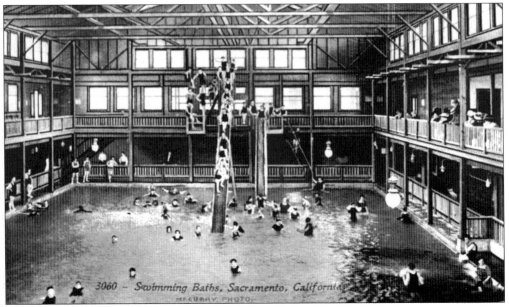

This c. 1920 postcard of the Riverside Swimming Baths shows a covered, two-story structure with two galleries and long, steep slides. Enormously popular with Sacramento residents and served by trolleys running down Riverside Boulevard, the Riverside Baths operated from 1909 to 1937, filled by what some called smelly, artesian well water. In 1937 the roof was removed, and the baths became the Land Park Plunge. It eventually closed, perhaps due to the polio scare, and the Temple B'Nai Israel bought the land and built their temple on the site in the 1950s. (Courtesy of SAMCC.)

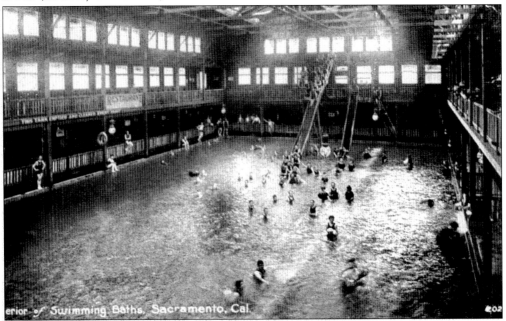

Here is another view inside the old swimming baths. A restaurant was on the left-hand side. Some recall that the water was warm, and others seem to think it was cold. Most agree on the memory of the smell of rotten eggs from the artesian well water. (Courtesy of SAMCC.)

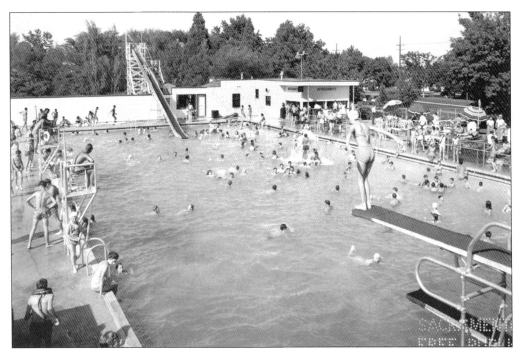

Pictured in this 1937 photo, the long, high slide and diving boards of the Land Park Plunge were popular with local kids. (Courtesy of Special Collections of the Sacramento Public Library.)

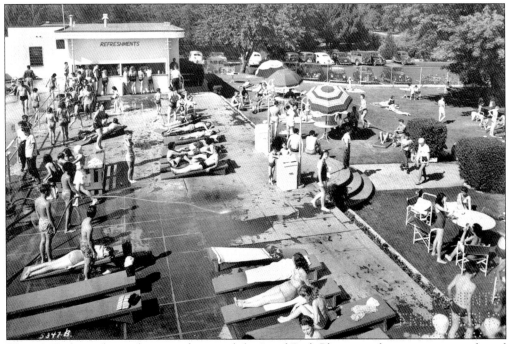

This 1947 photo shows the grounds around the Land Park Plunge, with concession stands and lounging chairs. The entrance was on Riverside Boulevard, across from the William Land Park panhandle. (Courtesy of Special Collections of the Sacramento Public Library.)

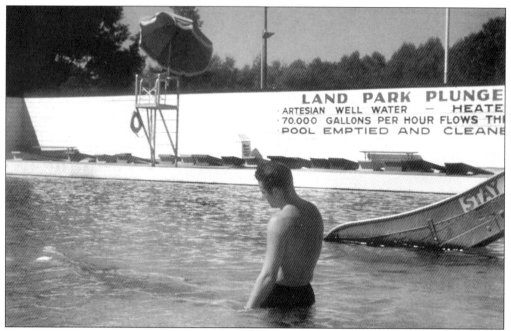

The Riverside Baths/Land Park Plunge owners and managers boasted that the pool was cleaned daily with fresh artesian well water. Unfortunately, the management also enforced a racist policy, as did most American cities at the time. On a hot summer day in 1921, a 13-year-old Hawaiian girl was prohibited from swimming in the baths because she belonged to a "dark race." While many Land Park residents have fond memories of swimming in the baths, most non-Caucasians remember being excluded and watching through the fence. (Courtesy of SAMCC.)

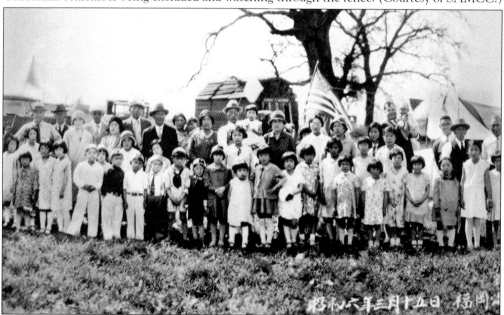

Members of the Fukuoka Foreign Association gathered on March 15, 1931 at a spring sports meet in the Riverside district. (Courtesy Library, California State University, Sacramento. Image no. JCFOLIO1:13.)

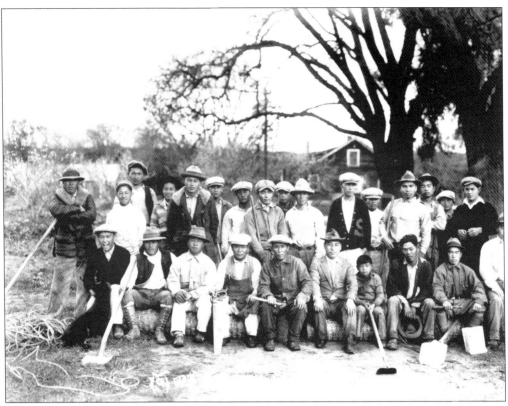

Many Japanese Americans and Japanese immigrants lived in the South Land Park and Riverside areas. To serve the children of farmers in the area who could go to school only on Saturday because they were needed in the fields the rest of the week, the community established a Japanese Language School on the Riverside Road, just behind the current Cabrillo Club. In this 1928 photo, one of the workers appears to be a high school letterman from Sacramento High. (Courtesy Library, California State University, Sacramento. Image no. JC17:217.)

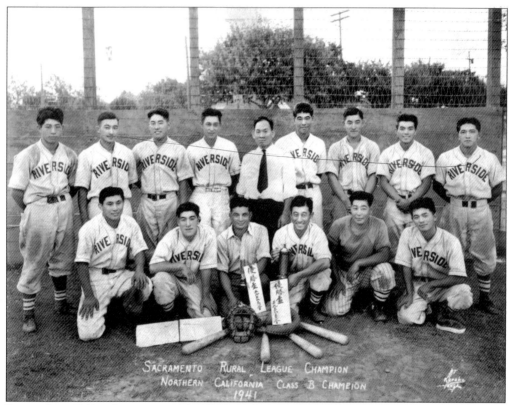

Pictured in 1941, after winning the Sacramento Rural League Championship, are Japanese baseball players from the Riverside District. In 1944, Tad Takeuchi (back row, on the right) was killed in action during World War II while rescuing a lost battalion. (Courtesy Library, Cailfornia State Universtiy, Sacaramento. Image no. JC17:157.)

The South Side stables were on the Riverside Road, just below the Old White House Saloon. The saloon site later became the Hereford House, and then the Riverside Clubhouse. The mailman would drop off horses here after his run. This photo was taken in 1943, and the stables were torn down in 1953. (Courtesy of SAMCC.)

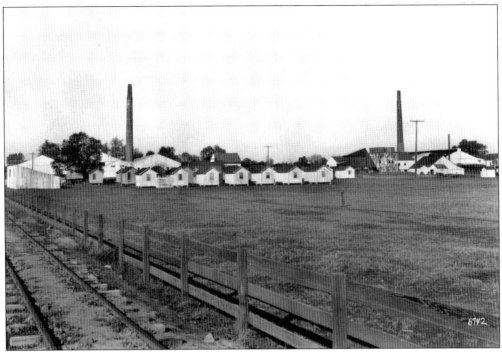

This 1915 photo shows the towers of what was known as the "brickyard" (most likely the Sacramento Brick Company) located off Riverside, with laborers' cottages in the front. The area south of "Y" Street was known for brick making. (Courtesy of SAMCC.)

This building, which may have been a granary at one time before it was converted into housing, was located on the Riverside Road, possibly around Eighth Avenue. (Courtesy of SAMCC.)

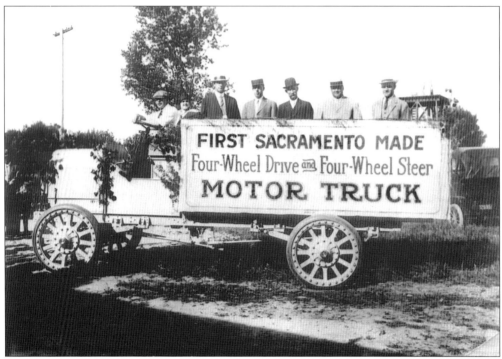

The Golden West Motor Company made four-wheel drive and four-wheel steer motor trucks at their plant on Seventh Avenue, one block west of Riverside (near the current Vic's Ice Cream). In operation from 1913 to 1922, the company went through three reorganizations, one name change, five models proposed, two trucks manufactured, and only one truck sold, believe it or not. (Courtesy of SAMCC.)

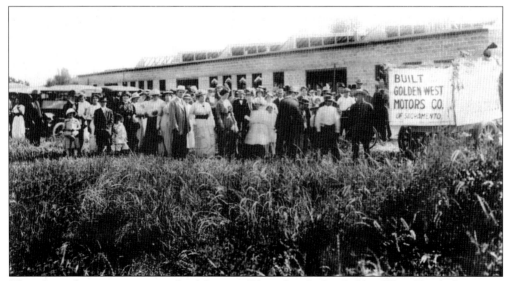

This photo shows spectators and celebrants affiliated with the Golden West Truck Company. The location is most likely the factory in the Riverside area. (Courtesy of Special Collections of the Sacramento Public Library.)

In this photo, a metal spiral form is being lifted by pulley off a shaping mechanism known as a spider. The spiral form was used to create huge, concrete sewer pipes. (Courtesy of the City of Sacramento.)

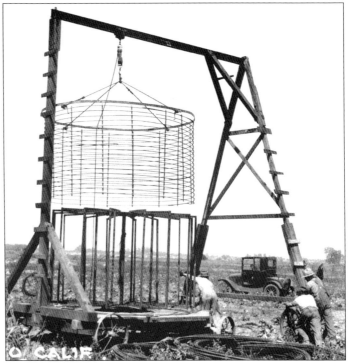

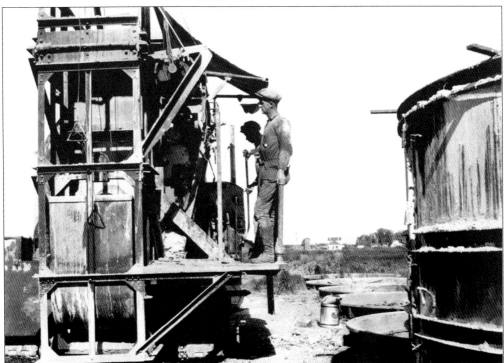

As evident in this 1927 photo of the Bond Sewer project, building a sewer was hard, dirty work. In the distance are houses along Riverside Boulevard and a silo-shaped building that is still on Eighth Avenue. (Courtesy of the City of Sacramento.)

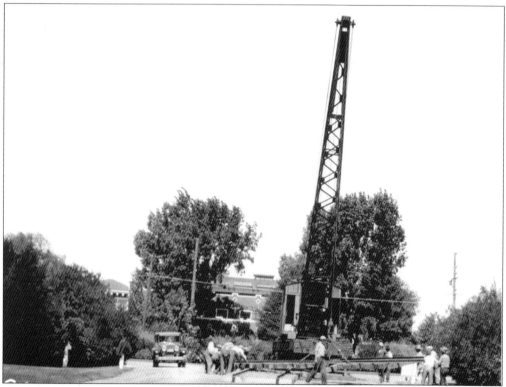

The Bond Sewer project modernized the sewer and runoff system south of Sacramento with a sump pump and new sewer connections at Riverside and Eleventh. Here a huge steam crane is being moved to the construction site, along what appears to be Riverside Boulevard in front of the old Riverside Baths. (Courtesy of the City of Sacramento.)

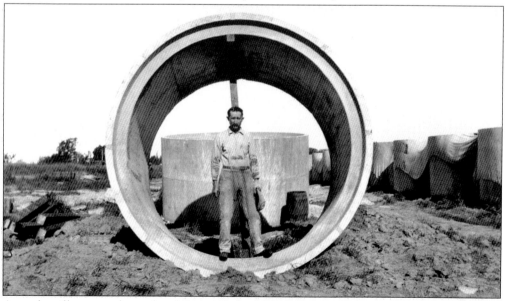

A worker illustrates the scale of the nine-foot-diameter pipes that were used for the sewer project. (Courtesy of the City of Sacramento.)

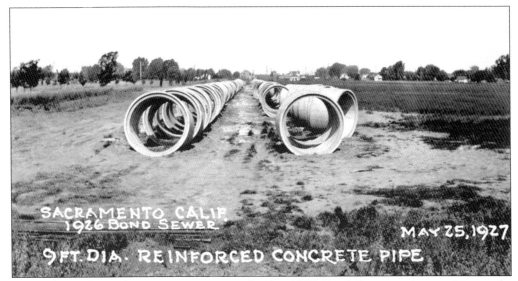

Pictured are slices of concrete sewer pipe for the 1927 Bond Sewer project, waiting to be installed in the ground. The houses directly behind the rows of pipe are along Eighth Avenue and are still there, and those to the right of the pipe are along Riverside. Ninth, Tenth, and Eleventh Streets had not yet been laid out. (Courtesy of the City of Sacramento.)

In 1977, artist Horst Liessl painted several trompe l'oeil murals on the walls of the huge tank at the Riverside water treatment plant. Eventually, neighboring residents grew tired of the paintings, complained to the City, and they were painted over. (Courtesy of the City of Sacramento.)

Here's the Incredible Hulk busting out of this tank at the Riverside Water Treatment plant. (Courtesy of the City of Sacramento.)

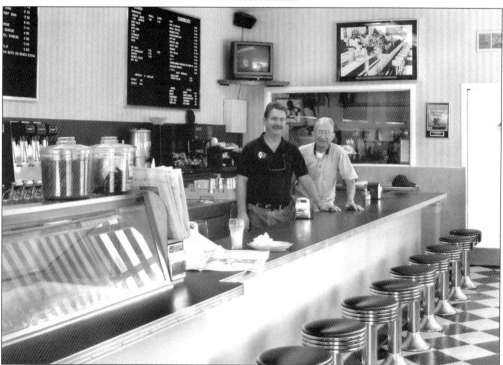

Craig Rutledge and his father, Ash, stand behind the counter at Vic's in 2004. In business for almost six decades, the shop hasn't changed very much. (Courtesy of the author.)

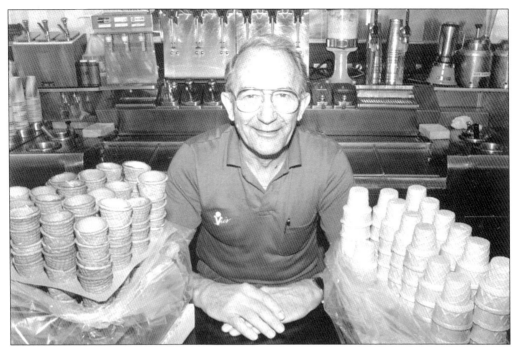

A Land Park resident for decades, Ashley Rutledge remembers courting his wife when she took horseback riding lessons at the long-gone stables near Land Park. He raised his three children in the neighborhood and they all still live in old Land Park. (Courtesy of SAMCC.)

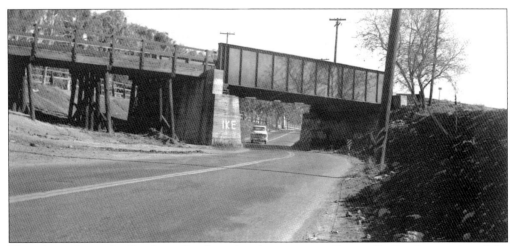

This photo shows the Southern Pacific railroad overpass on Sutterville Road, just west of the current Land Park Drive, looking east. On the left, the zoo's fence can be seen under the trestle. Later the trestle was filled in to form a levee, the underpass was removed, and Sutterville was raised to go over the levee. Note the "IKE" graffiti on the concrete. (Courtesy of SAMCC.)

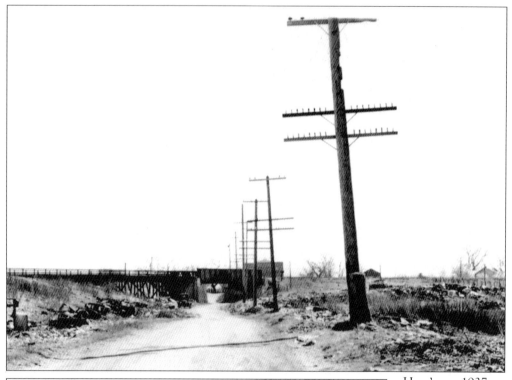

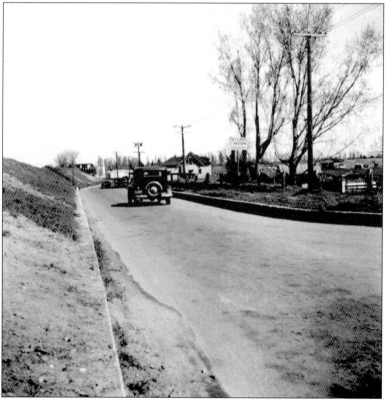

Here's a c. 1937 view looking east on Sutterville Road. It's not much more than a one-lane road surrounded by fields. (Courtesy of SAMCC.)

This photo of Riverside Boulevard, looking north from Sutterville Road, was taken in March 1937. The Sacramento River is behind the levee on the left. (Courtesy of SAMCC.)

The Southern Pacific railroad tracks near Riverside Boulevard used to be raised above the fields. Later the trestle was replaced with a levee. The Holy Spirit School is visible on the right, behind the trestle. (Courtesy of SAMCC.)

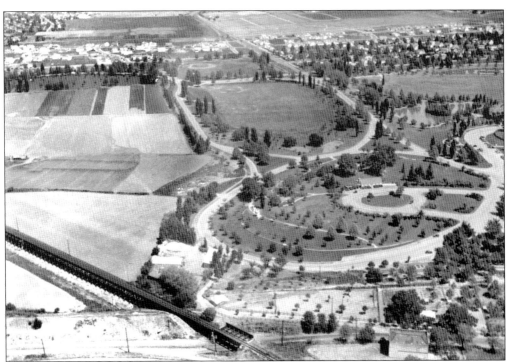

This 1930s aerial view of south and west Land Park looks north from the intersection of Sutterville, Land Park, and Del Rio. The old Sutterville Brewery building is in the bottom right corner. Also visible are the Southern Pacific railroad tracks, the grounds and ball fields of William Land Park, and acres of crops that would soon be turned into housing developments. (Courtesy of SAMCC.)

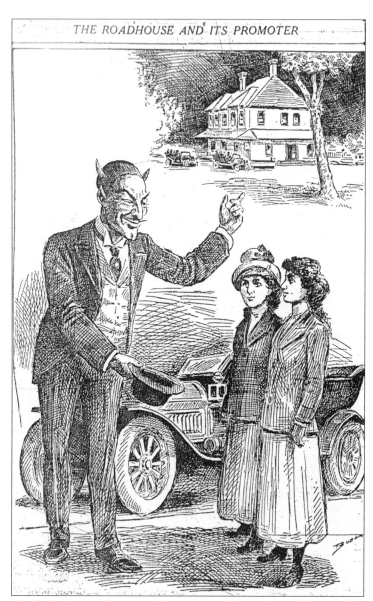

The notorious Bush Quinn roadhouse at the corner of Riverside and Sutterville inflamed local passions against the Riverside district. Run by a man named Bush Quinn, the roadhouse reputedly sold liquor to "girls and minors." In 1911, the *Sacramento Bee* wrote:

> On Monday afternoon, the Board of Supervisors of Sacramento County unanimously passed a resolution permitting this sink of iniquity, this foul plague-spot, to transfer its license across the road so as to be just without the border of Greater Sacramento. This was done for the purpose of permitting this breeding-place for Satan to continue in existence – for undoubtedly it would be wiped out if it remained within the city limits. How do the decent people of Sacramento, city and county, like the complicity of their Board of Supervisors with the Devil, in helping the Devil in the Devil's dirtiest work?

(Courtesy of the *Sacramento Bee*.)

Three
WILLIAM LAND PARK

This 1959 photo shows Fairytale Town's "Crooked Mile," before overgrown foliage enveloped it. Pictured are two little girls with fairy wings, and a little Robin Hood. (Courtesy of SAMCC.)

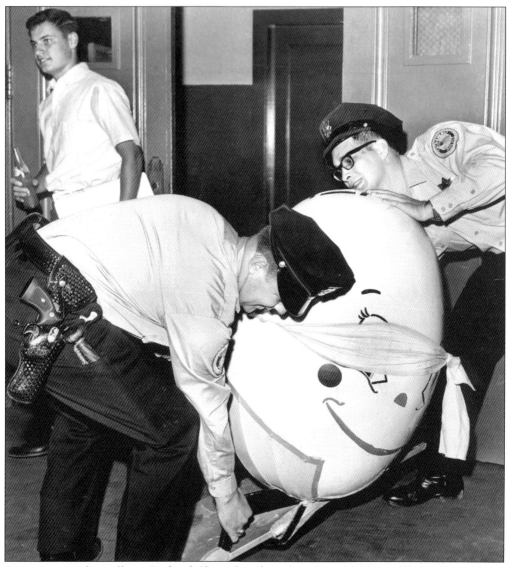

Sacramento police officers Richard Sloan (in glasses) and Jerald Morin filled in for "all the king's horses and all the king's men" to get Humpty Dumpty back on the Fairytale Town gate again. Humpty was stolen in August 1964, and the officers recovered him from the trunk of a car about a week later. (Courtesy of SAMCC.)

Carole Sulli was the "fairy godmother" of Fairytale Town in 1964. (Courtesy of SAMCC.)

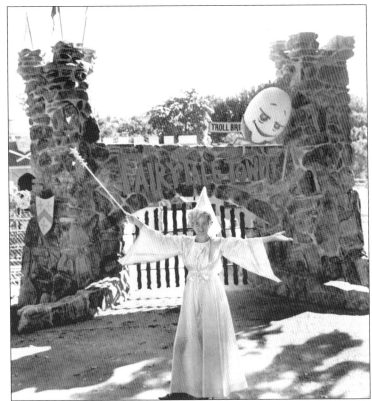

In this 1959 aerial view of Fairytale Town, no walls or fences surrounded the park. (Courtesy of SAMCC.)

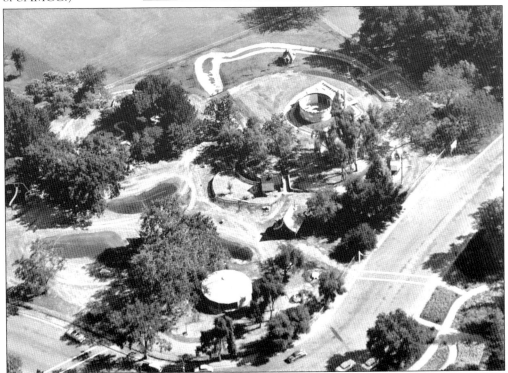

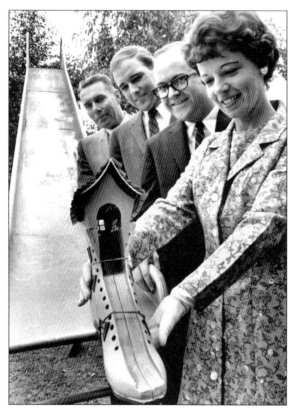

In this 1968 photo, Mrs. Douglas Fraleigh, secretary of the Fairytale Town board of directors, holds a model of the Mother Goose slide, just after the new slide was installed. Also pictured, from front to back, are William Richards, Dave Clark, and Ben Wichard. The City of Sacramento and the Junior League were instrumental in bringing this children's storybook land to life in 1959. (Courtesy of SAMCC.)

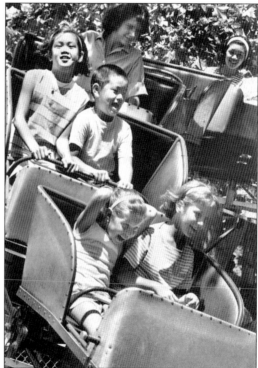

Children have been enjoying the rides at Funderland since 1941. Here kids thrill to the dragon roller coaster in 1964. (Courtesy of SAMCC.)

In this late 1930s or early 1940s photo, John Hamlyn's father escorts him around the Land Park pony ride ring. (Courtesy of John Hamlyn.)

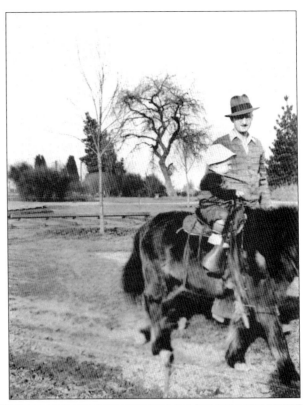

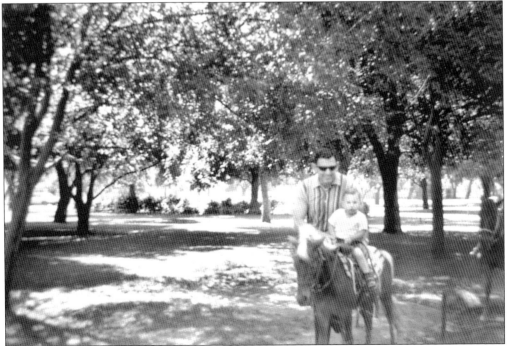

Gus Gianulias took his son Chris around the pony ring in 1967. (Courtesy of the Gianulias family.)

In this 1973 photo, the ponies head for the barn after a long day at the pony rides attraction in William Land Park. (Courtesy of SAMCC.)

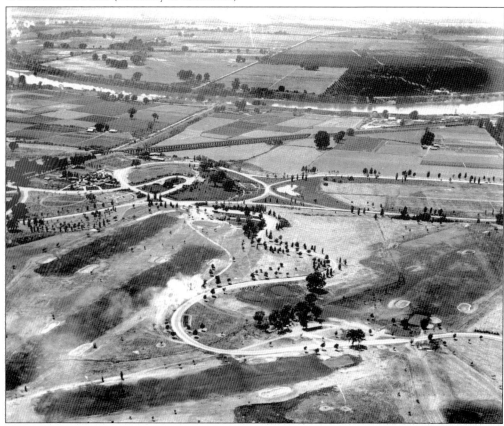

This 1931 aerial view shows the Sacramento Zoo, with the Southern Pacific railroad visible just below the river. Note the lack of development, and the open fields surrounding the zoo and park. The zoo was relegated to a small corner of the park at Sutterville and Land Park Drive. (Courtesy of SAMCC.)

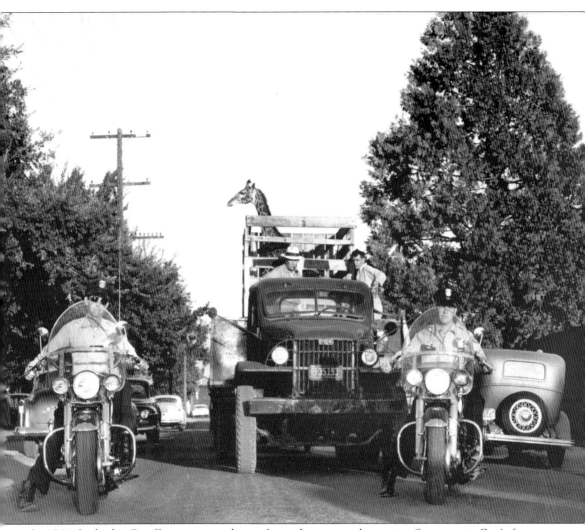

In 1961, Lady the Giraffe was escorted in style, on her way to becoming Sacramento Zoo's first giraffe. (Courtesy of the Sacramento Zoo.)

John Hamlyn (in the white sailor hat) and friends are shown here in front of the old Sacramento Zoo in the early 1940s. (Courtesy of John Hamlyn.)

The futuristic Sacramento Zoo entrance and concession stand was built in 1961. (Courtesy of SAMCC.)

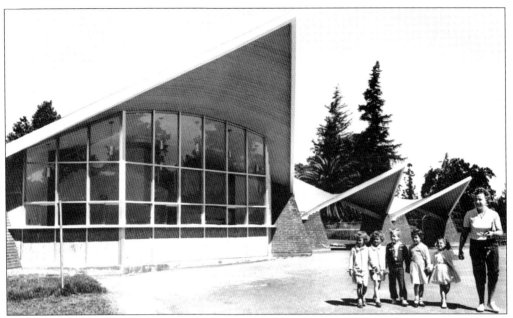

The newly renovated zoo was a big hit with local residents, especially kids. (Courtesy of SAMCC.)

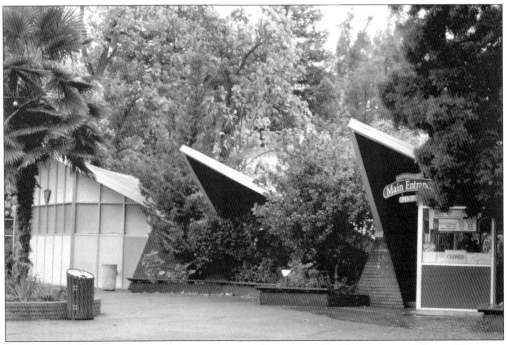

This present-day view shows the zoo structures almost engulfed by rampant foliage. (Courtesy of SAMCC.)

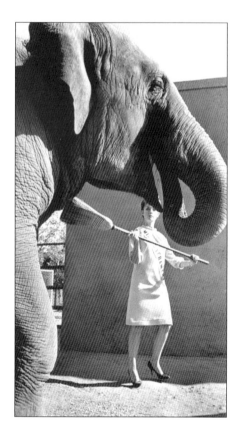

Miss Sacramento of 1967, Edie Duckworth, cleans an elephant at the Sacramento Zoo. She was helping to promote a junior chamber of commerce white elephant sale. (Courtesy of SAMCC.)

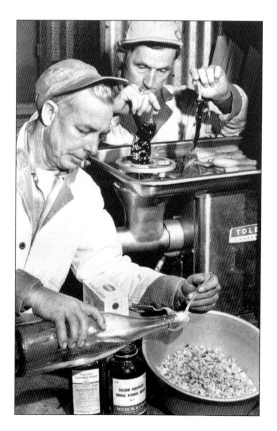

Many meals are prepared daily at the Sacramento Zoo to exacting specifications, as shown in this photo from the early 1960s. (Courtesy of SAMCC.)

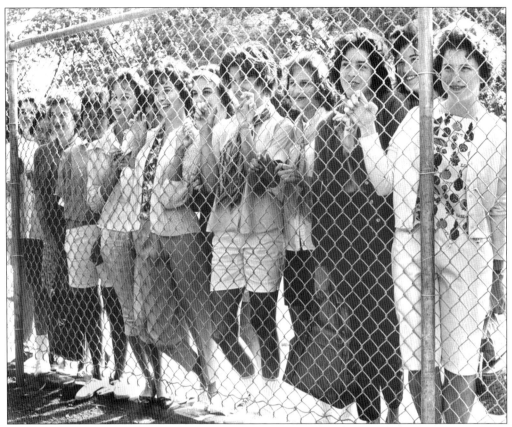

In this early 1960s photo, girls from St. Francis High watch through the fence of the Sacramento Zoo. (Courtesy of SAMCC.)

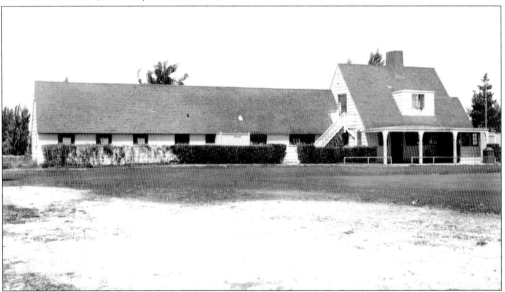

The Land Park golf course was the first golf course in Sacramento, and opened for play in 1924. Pictured is the William Land Park golf pavilion. (Courtesy of SAMCC.)

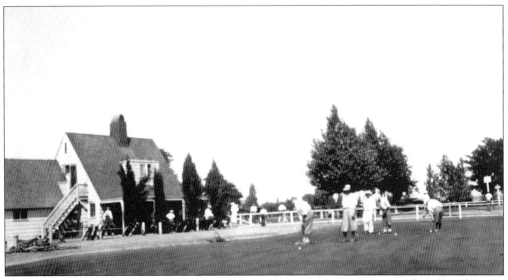

This 1931 photo shows the "Land Park Putters" in front of the William Land Park golf course clubhouse. The stylish knickers they wore were called "plus fours" because they ended four inches below the knee. (Courtesy of SAMCC.)

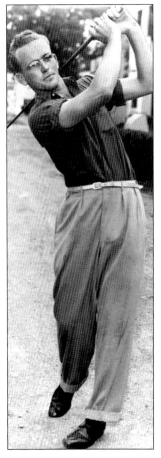

Tommy Harris was a young golfer who won the city's youth championship, playing out of the William Land Park golf course. (Courtesy of Cindy Anderson.)

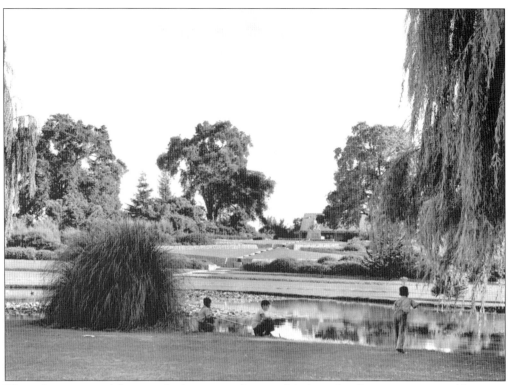

Three boys enjoy fishing and playing in the pond below the Swanston statue. (Courtesy of SAMCC.)

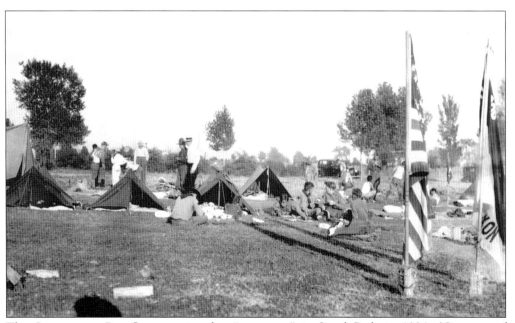

The Sacramento Boy Scouts enjoyed a "camporee" in Land Park in 1934. (Courtesy of Alan O'Connor.)

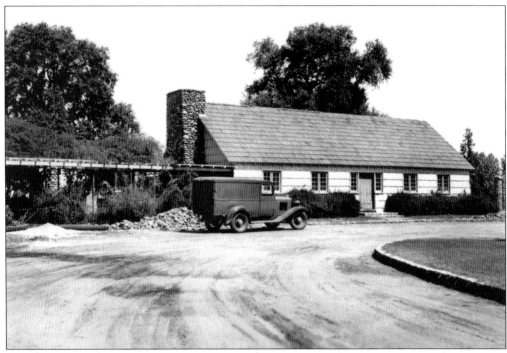

The Land Park Pavilion sat on the site of the current zoo's playground, overlooking the Swanston Statue and the ball fields. It was also used as a dance hall. (Courtesy of SAMCC.)

This 1930 photo of the entrance to William Land Park from Riverside Boulevard shows the trolley tracks that stopped at the railroad trestle near Sutterville Road. (Courtesy of SAMCC.)

The William Land memorial across from City College was designed by noted architect Leonard F. Starks, in honor of William Land (1837–1911), who gave Sacramento the park. The plaque contains a quote by Virgil: "The noblest motive is the public good." (Courtesy of Special Collections of the Sacramento Public Library.)

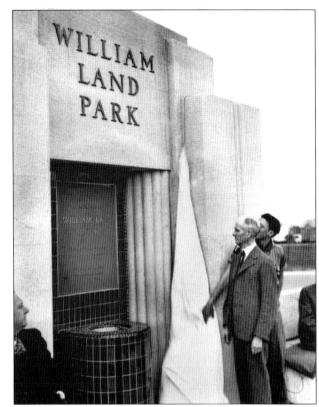

In this photo of the William Land memorial ceremony, you can see clearly across to Sutterville Road. (Courtesy of SAMCC.)

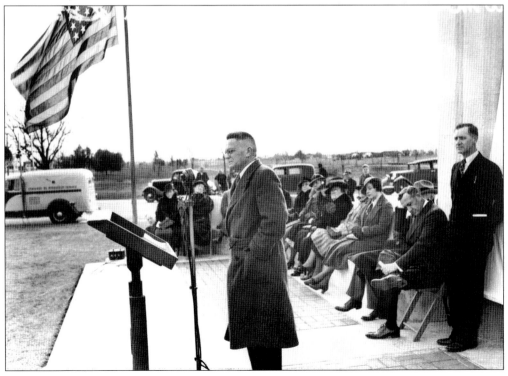

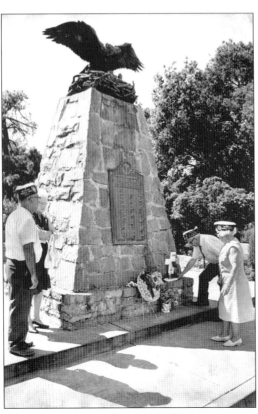

In this 1973 photo, World War I veterans lay wreaths and other floral tokens at foot of an eagle-topped monument honoring Sacramentans who gave their lives. (Courtesy of SAMCC.)

William Land Park was host to Sacramento's first police training academy in 1953. (Courtesy of SAMCC.)

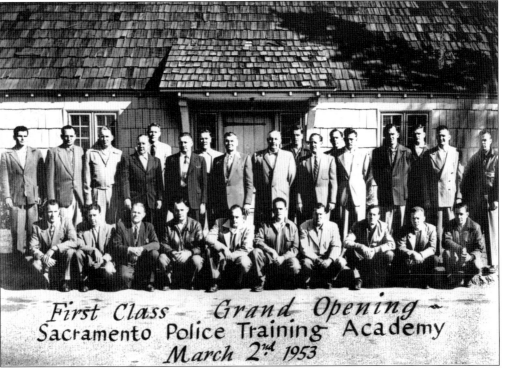

First Class – Grand Opening –
Sacramento Police Training Academy
March 2nd 1953

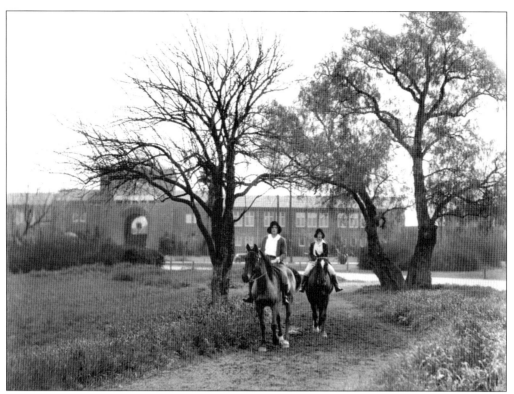

Horseback riding was popular in the Land Park area, and horses were a common sight in and out of the park. This 1926 photo shows Sacramento Junior College (later Sacramento City College) in the background. The rental stables were at the corner of Freeport and Sutterville. (Courtesy of Special Collections of the Sacramento Public Library.)

This building used to be just a restroom in Land Park. It was later converted to include the classroom for the Tiny Tots preschool program. The building still exists next to the playground and wading pool. (Courtesy of SAMCC.)

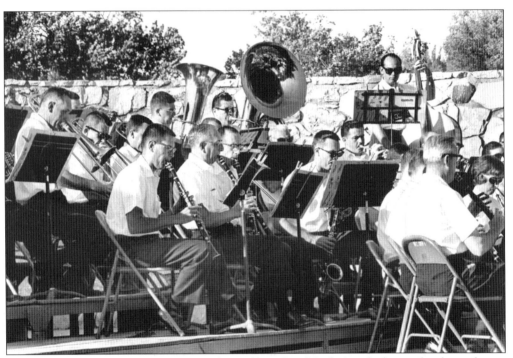

The William Land Park Amphitheatre has been the host to concerts, plays, and other productions over the years, as evident in this 1963 photo of a band concert that was part of the "Music in the Park" series. (Courtesy of SAMCC.)

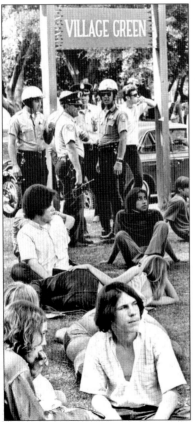

The Village Green, that large slab of concrete on the corner of the park near Freeport and Sutterville, was a popular place for concerts in the 1970s. This is a photo of a peaceful 1979 rock concert, although it looks more like a sit-in. (Courtesy of SAMCC.)

Four

GRACIOUS NEIGHBORHOODS

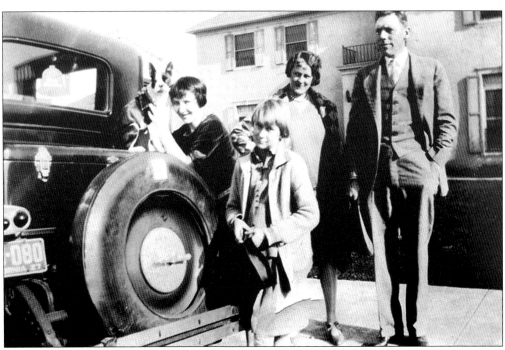

In this *c.* 1927 photo, a patient dog, an unidentified friend, Julie Spickard, Effie Spickard (her mother) and an unidentified man, pose outside the Spickard home at 3715 College Avenue. Claude Spickard, Julie's father, was a Packard auto dealer in Sacramento. (Courtesy of Julie DiLoreto.)

Many Modern New Homes Center in 11th Ave. Are

The newspaper used to publish the names of area homebuilders. This 1931 clipping showcases homes in the College Tract neighborhood. (Courtesy of John Hamlyn.)

Eleanor Hamlyn holds her son John on the site of their in-progress College Tract home on Eleventh Avenue. John recalls that his mother used to say that one could see all the way to downtown Sacramento across the empty fields. (Courtesy of John Hamlyn.)

Estelle Opper and her sister Carolyn Smith grew up in this home that their father had built on Teneighth Way. Estelle remembers her father standing in the driveway to watch across the fields for his daughters to come home from Cal Junior High on Land Park. (Courtesy of Estelle Opper.)

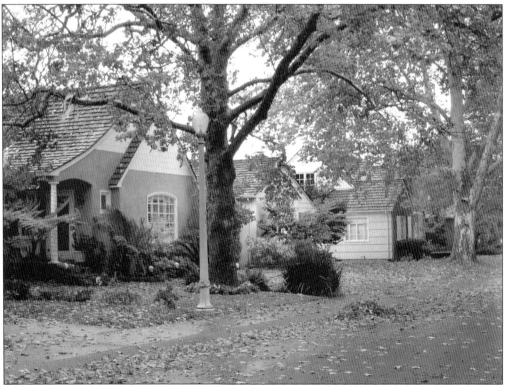

Here is the same view on Teneighth Street, decades later. The many changes include the addition of neighboring homes, street lights, modified roof lines and windows, and mature trees where once were only saplings. (Courtesy of the author.)

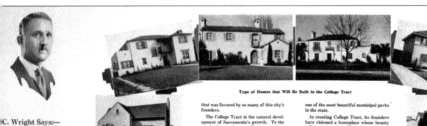

Type of Homes that Will Be Built in the College Tract

C. Wright Says:—

A. R. Gallaway, Jr. S

ONG ago, Mother Nature created the place ideal for Sacramento to build their homes. Many pioneers of this city realized this and believed that Sacramento should have been originally built on the gentle sloping land that now marks the site of the College Tract and William Land Park.

But it was left to the marvelous expansion of this city to give recognition to the foresight of the old timers. In the Wright & Kimbrough College Tract, Sacramento realizes today the homeplace beautiful

that was favored by so many of this city's founders.

The College Tract is the natural development of Sacramento's growth. To the south, this city is expanding because it is the only logical direction for it to grow.

College Tract is for those who love beauty; for those who seek the contentment of mind that ideal home life brings; for those who want to build their dream homes in a perfect environment out in the sunshine and fresh air—where a splendid golf course lies at your door; where you can enjoy complete rest and peace of mind; where you can raise your children in happy, healthful surroundings.

College Tract immediately adjoins William Land Park on the north. Now one of the city's scenic spots, this 250 acre playground will in a few years become

one of the most beautiful municipal parks in the state.

In creating College Tract, its founders have visioned a homeplace whose beauty will be in keeping with the beauty of its environs. Grace and charm are given its design by circular divisions and curving avenues. Large sites have been provided, many of them facing William Land Park.

Harmony and beauty in architecture is assured through the College Tract Art Jury who together with wise restrictions will assist home builders in planning homes that will be a credit to themselves and to the district. Wonderfully fertile soil and perfect drainage will make possible landscape effects that will add to the beauty of the homes.

College Tract is within a stone's throw of the new Junior College, an educational

advantage of great importance to every family.

College Tract is for you—a homeplace solely devoted to the development of ideal living conditions and in no sense a subdivision with the one object of selling lots. You are invited to investigate College Tract with the expectation of finding your perfect home site—where you will want to build at once and enjoy the utmost that life can give you—true home happiness. An investigation incurs no obligation whatever.

College Tract is a Revelation in Home Development

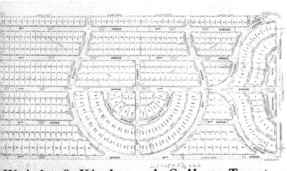

Wright & Kimbrough College Tract
Large Homesites—10% Down SMALL MONTHLY PAYMENTS

Asphalt Streets, Curbs, Gutters, Sidewalks, and Electroliers to be Installed on the 10 Year Bond Plan

Wright & Kimbrough
Owners and Original Subdividers

Main 832

College Tract is Close In—

Study the above map closely. It may be surprising to you to note that the center of Wright & Kimbrough College Tract is closer to 10th and "K" Sts. than 42nd and "J", East Sacramento.

With the impetus of the New Junior College, William Land Park and a very definite expansion to the south now in progress, this entire district will develop with marked rapidity.

Sacramento is now a city of more than one hundred thousand people and today faces the era of its greatest progress. There is a very definite need for a homeplace like the College Tract and every lot purchaser here at the most moderate sale prices may be assured that his investment will continue to grow in value.

Wright & Kimbrough
Owners and Original Subdividers
817 "J" St Sacramento Main 832

Wright & Kimbre

Colleg
Trac

This 1930s marketing brochure for new home plots makes College Tract look something like the city of Oz. It describes the area as "a perfect environment outside in sunshine and fresh air . . ."

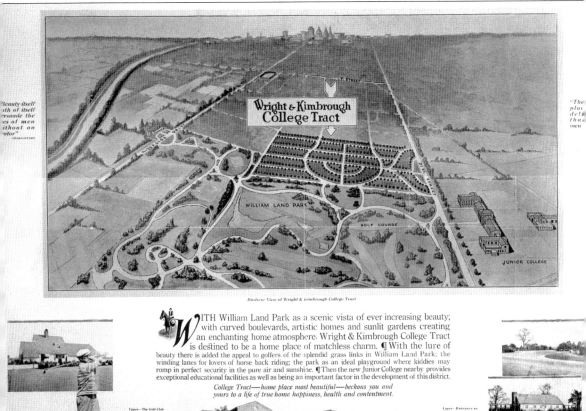

"The
plac
delt
tha
own

Birdseye View of Wright & Kimbrough College Tract

WITH William Land Park as a scenic vista of ever increasing beauty; with curved boulevards, artistic homes and sunlit gardens creating an enchanting home atmosphere. Wright & Kimbrough College Tract is destined to be a home place of matchless charm. ¶ With the lure of beauty there is added the appeal to golfers of the splendid grass links in William Land Park; the winding lanes for lovers of horse back riding; the park as an ideal playground where kiddies may romp in perfect security in the pure air and sunshine. ¶ Then the new Junior College nearby provides exceptional educational facilities as well as being an important factor in the development of this district.

College Tract—home place most beautiful—beckons you and yours to a life of true home happiness, health and contentment.

Upper—The Golf Club House at William Land Park.

Lower—Teeing off from the first.

Upper—Entrance to William Land Park.

Lower—Dance Pavilion William Land Park.

The New Junior College

". . . where a spacious golf course lies at your door; where you can enjoy complete rest and peace of mind; where you can raise your children in happy, healthful surroundings." (Courtesy of SAMCC.)

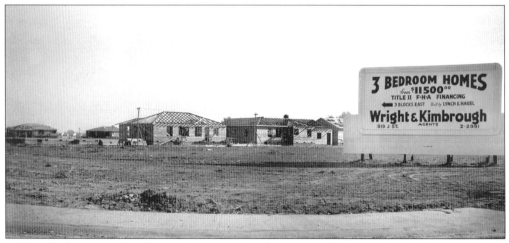

A three-bedroom Land Park area home went for $11,500 in the 1940s—a pretty steep price at the time. (Courtesy of SAMCC.)

This peaceful, rural lot at 3648 Lincoln Way in College Tract was still undeveloped in June of 1935. (Courtesy of SAMCC.)

This 1930s photo shows the corner of Cordano and Land Park Drive just prior to its development. The white water tower of Sacramento Junior College is visible in the background. Holy Spirit Church was later built at this corner. (Courtesy of SAMCC.)

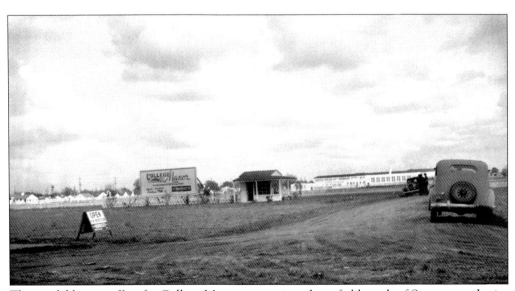

This model homes office for College Manor was set in a dusty field north of Sacramento Junior College. (Courtesy of SAMCC.)

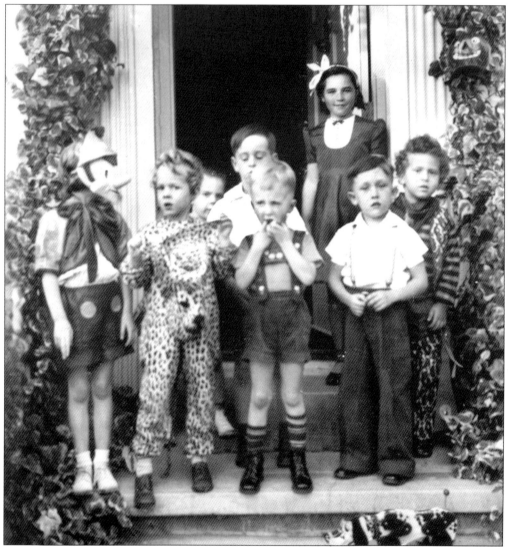

That's Supreme Court Justice Anthony Kennedy in the leopard suit, and attorney John Hamlyn in the lederhosen, in this early 1940s photo of Halloween in College Tract. (Courtesy of John Hamlyn.)

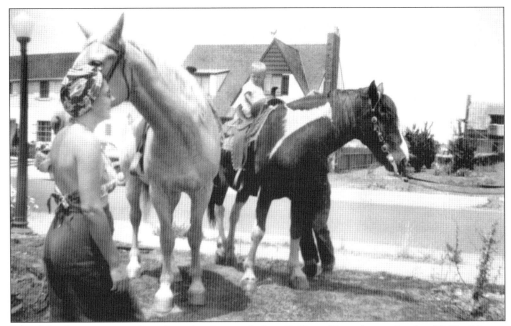

John Hamlyn is pictured on horseback outside his College Tract home in the 1940s. Horses were still common sights throughout Land Park, partly because of the popular College Stables on Freeport at Sutterville, as well as the area's agricultural and ranching roots. (Courtesy of John Hamlyn.)

Cindy Sullivan Anderson and her friend Karen McMasters are shown in this 1950s photo at Cindy's house at Seventh and Freeport, catty-corner from McClatchy High. (Courtesy of Cindy Anderson.)

Joe Genshlea plays outside his home on Twelfth Avenue in the college. (Courtesy of Joe Genshlea.)

During World War II, Americans were encouraged to grow victory gardens to help the war effort. In this 1943 photo, Joe Genshlea Jr., his mother, Elva, and his sisters Eleanor and Mary Clare work at the potato gardens in William Land Park alongside Thirteenth Avenue. (Courtesy of Joe Genshlea.)

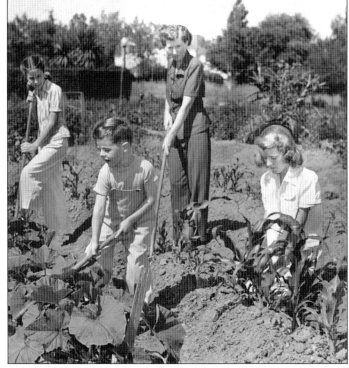

74

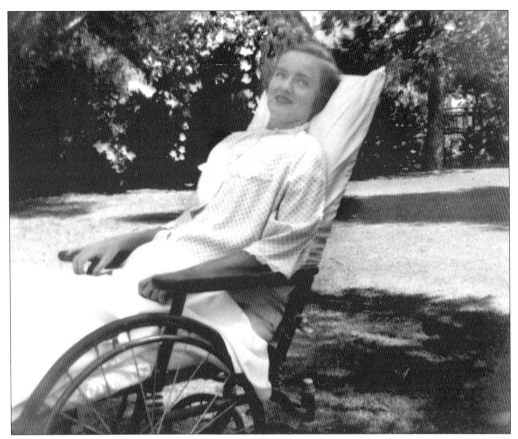

Mag Cavanaugh Lyons, Bartley Cavanaugh's daughter, contracted polio at age 18, just after graduating from high school. This photo was taken at her Fourth Avenue home, just after her return from a treatment center in Warm Springs, Arizona. Mag's brother Bart Jr. also contracted polio. (Courtesy of the Lyons family.)

Pioneer Charles Swanston's son George built a magnificent home at the end of rows of palms, on the family ranch off Riverside Boulevard. George died in 1923 and the house was eventually sold. The ranch land was developed into a residential tract. (Courtesy of SAMCC.)

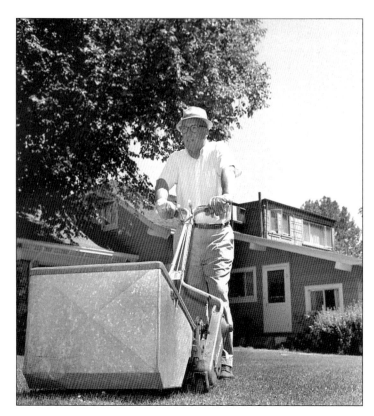

Bartley Cavanaugh Jr. was Sacramento's city manager between 1946 and 1964. In this 1961 photo, the grandson of pioneer Bartley Cavanaugh Sr. is mowing his lawn at 900 Fourth Avenue. Cavanaugh's father, also Bartley Cavanaugh, had a ranch off Riverside Boulevard, just north of the current Sacramento Zoo. (Courtesy of SAMCC.)

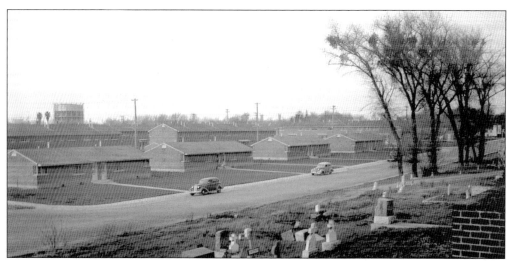

The New Helvetia public housing project was built in 1940s on a large tract of land west of the old city cemetery. Bartley Cavanaugh the younger was instrumental in developing the project. (Courtesy of SAMCC.)

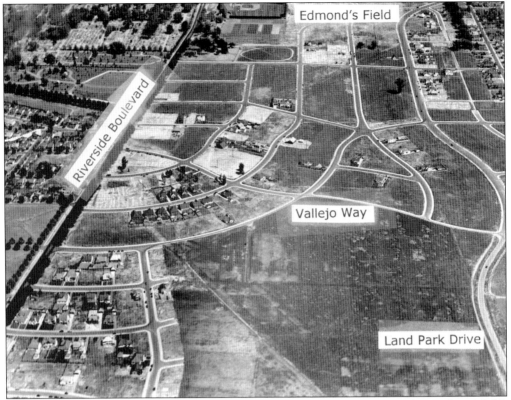

This aerial view of Land Park, most likely from the 1930s, shows the areas of agricultural fields that are now filled with houses. (Courtesy of Joe Genshlea.)

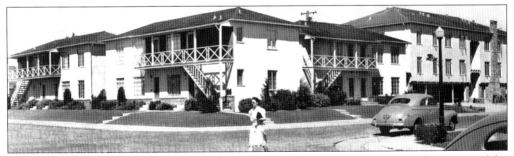

This apartment complex at Twenty-second and Eleventh, was built in 1948 and was part of the "better homes and gardens" building ideals that swept Sacramento in the 1940s and 1950s. (Courtesy of SAMCC.)

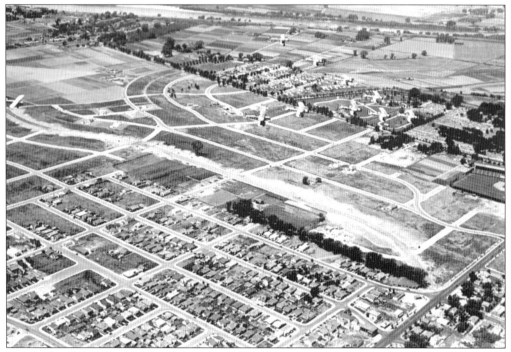

Charles Lindbergh crossed the Atlantic in 1927 and, upon returning to the United States, flew a victory tour of most of the states. This 1928 photo showing airplanes flying over Land Park was labeled both as a Lindbergh flight, and as a local military flight. Note that there is still a lot of empty land. Land Park Drive is seen in the middle of the image. (Courtesy of SAMCC.)

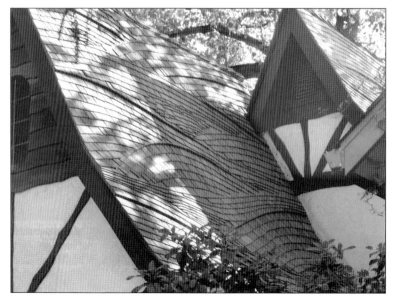

Beautifully crafted, intricate roofs like the one on this house are common throughout Land Park, giving it a fairytale quality at times. Painter Thomas Kinkade lived in Land Park until he was five years old, and credits the fanciful architecture of houses like this, as well as Fairytale Town, for inspiring his work. (Courtesy of Edgardo Isidro.)

Five
RELIGIOUS LIFE

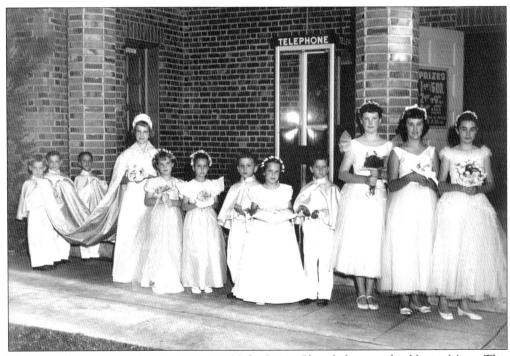

The annual May crowning ceremony at Holy Spirit Church honors the Virgin Mary. This photo is from the 1950s. (Courtesy of Holy Spirit School.)

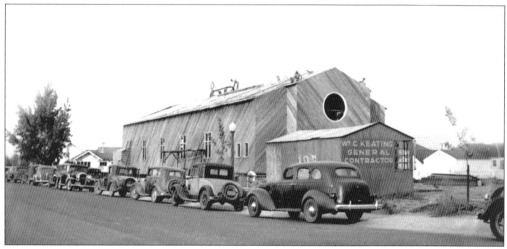

The Holy Spirit Church was built in 1940 at the corner of Land Park Drive and Cordano, in the middle of former agricultural fields. (Courtesy of SAMCC.)

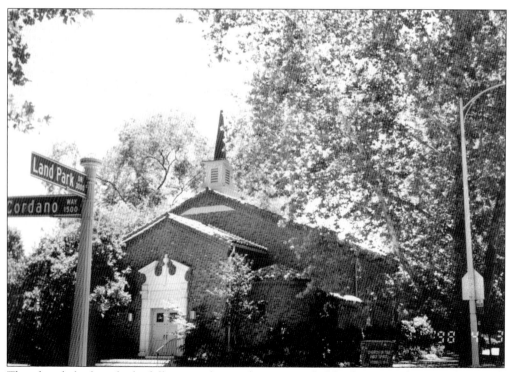

The church looks a little different today, and is surrounded by homes and trees. The parish serves all of Land Park, and oversees the Holy Spirit School. (Courtesy of Holy Spirit Church.)

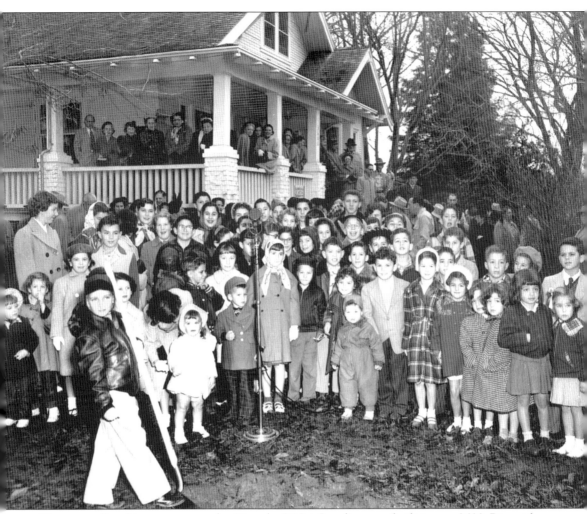

The groundbreaking ceremony for Temple B'Nai Israel's new facilities at 3600 Riverside Boulevard was held in 1954. The house in the background was later moved further up the street on Riverside Boulevard. (Courtesy of Temple B'Nai Israel.)

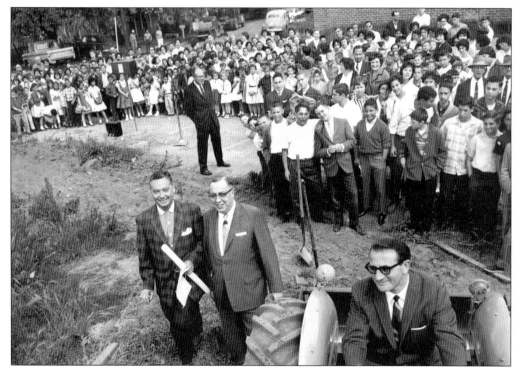

Rabbi Irving Hausman drives a tractor during groundbreaking ceremonies at the Temple B'Nai Israel's site on Riverside Boulevard. The road in the background is no longer there; it was absorbed by I-5 highway development during the 1970s. (Courtesy of Temple B'Nai Israel.)

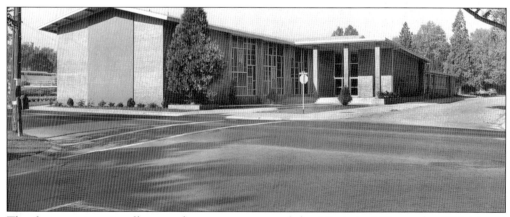

The first congregationally owned synagogue west of the Mississippi River, the B'Nai Israel Temple was founded during the gold rush in 1852, and met in various downtown Sacramento locations until the current site was developed. In the 1950s, the congregation bought land on Riverside Boulevard and built their modern temple where the Riverside Baths used to be. (Courtesy of Special Collections of the Sacramento Public Library.)

In 1999, two extremist anti-Semitic brothers firebombed Temple B'Nai. (Courtesy of the *Sacramento Bee* and Jay Mather.)

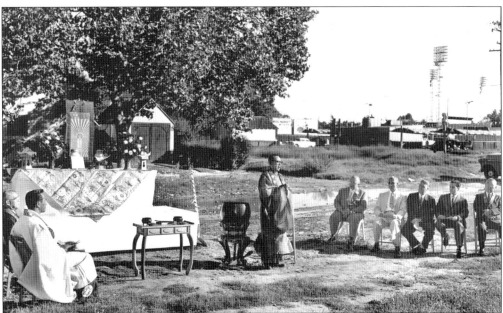

The groundbreaking ceremony for the Sacramento Buddhist Church at Riverside and X Street took place on October 18, 1958. The light standards of Edmonds Field can be seen on the right. Originally founded on December 17, 1899, the Buddhist Church of Sacramento is a Jodo Shinshu Buddhist Temple. (Courtesy of Gene Itogawa.)

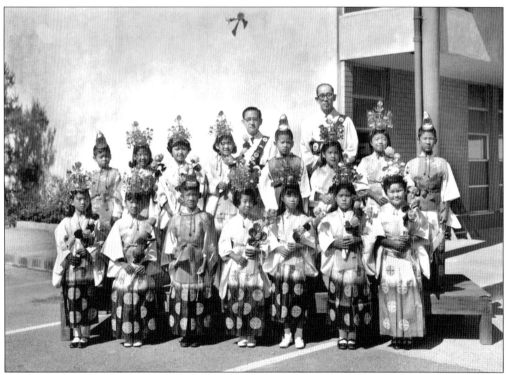

Here we see children dressed in traditional Japanese attire for the Ochigo parade ceremony outside of the Buddhist Church building at Riverside and X. (Courtesy of Gene Itogawa.)

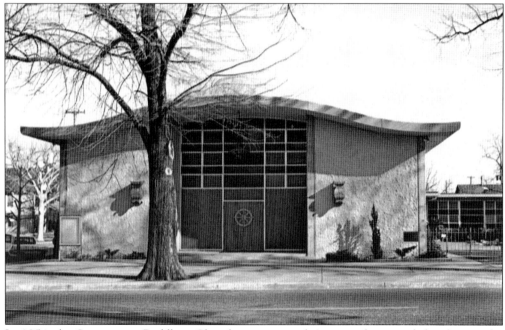

In 1954, the Sacramento Buddhist Church incorporated Asian architectural details into the design of their new building at Riverside and X, as shown in this postcard. (Courtesy Library, . California State University, Sacramento. Image no. JC20E:36.)

Six

SCHOOLS

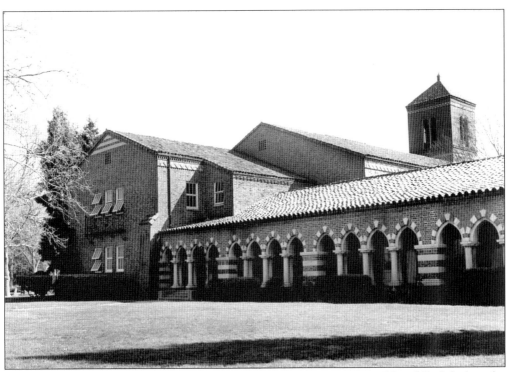

The beautiful California Junior High, with its distinctive tower, graced Land Park before the old buildings were torn down in 1980s. This lovely arcade faced Land Park Drive. (Courtesy of SAMCC.)

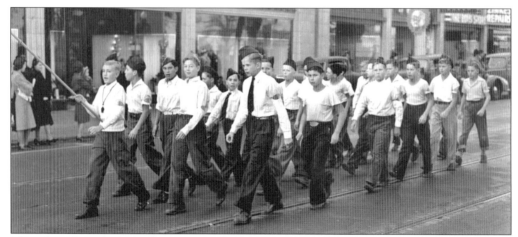

These boys from Crocker Elementary School marched through downtown Sacramento in 1940, perhaps as part of a parade. (Courtesy of California Middle School.)

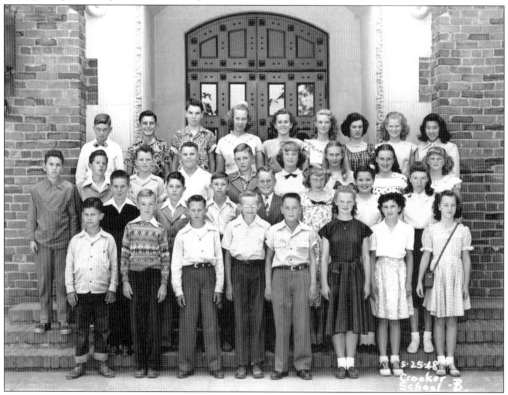

Members of Miss Bigelow's sixth-grade graduating class from Crocker Elementary in 1948 included, from left to right, (first row) James Longhoffer, Lester Davidson, Robert Peabody, Royal Brown, Wayne Willey, Julia Tully, Gwen Marsh, and Carol Dee Graver; (second row) Boyd Schulz, Joseph DeSalvo, Mahlon Picht, Bruce Keller, Dorothy Dozier, Karen Nielsen, and Kay Johnson; (third row) Bob King, Anthony Kennedy, Bruce Strickley, Mike Toomey, Jerry Todd, Patti Cordano, Marilyn Dettling, Marilyn Casey, and Pat Hogan; (fourth row) Dave Dozier, Gus Gianulias, Read Buckman, Nancy Kausen, Elizabeth Plummer, Doris Candland, Meride Brollier, Joan Mueller, and Pat Fong. (Courtesy of California Middle School.)

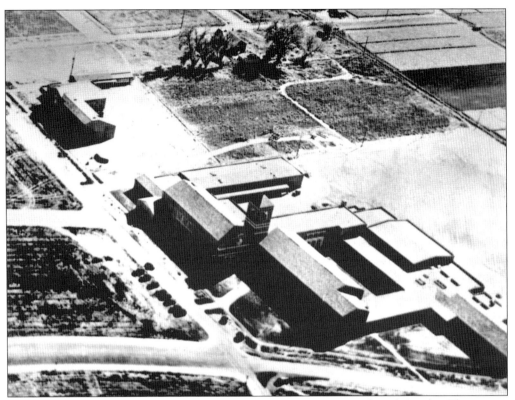

This aerial photo shows the campus shared by California Junior High and Crocker Elementary School, at the corner of Land Park and Vallejo. The campus was surrounded mostly by empty fields, and the lonely building in the trees at the top center of the photo was the Gianulias family home. (Courtesy of the Gianulias family.)

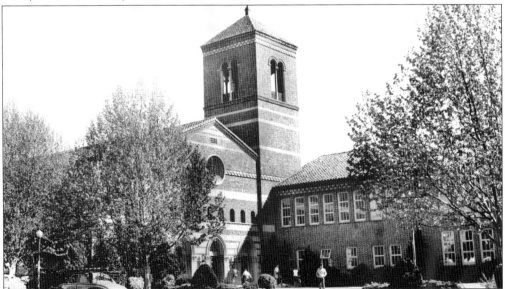

The high tower of California Middle School could be seen for miles. (Courtesy of California Middle School.)

This *c.* 1938 photo, most likely taken from Land Park Drive, shows the bell tower of the old California Junior High (later California Middle School) at the far right. The neighborhood is still more than half agricultural. (Courtesy of SAMCC.)

The John Muir Elementary School was on the site of the current Crocker-Riverside School on Riverside Boulevard. In this 1930 photo, trolley tracks are visible. Mag Lyons, city manager Bartley Cavanaugh's daughter, remembers being at recess when the malodorous "Gut Truck" went by on the way to the dump—loaded with smelly carcasses, most likely from slaughterhouses in the area. (Courtesy of SAMCC.)

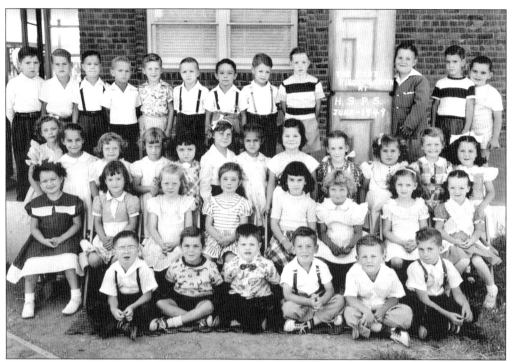

The Holy Spirit School was originally supposed to have been built on Land Park Drive in the current parking lot of the church. Local residents wouldn't allow a zoning variance for the school building and playgrounds, so in 1946, a large parcel owned by the Southern Pacific Railroad, just behind the current zoo, was purchased for $10,000. A convent for the teaching sisters was added to the school in 1947. (Courtesy of Holy Spirit School.)

The old Southern Pacific trestle is clearly visible in this photo of a student standing on the grounds at Holy Spirit School. (Courtesy of Holy Spirit School.)

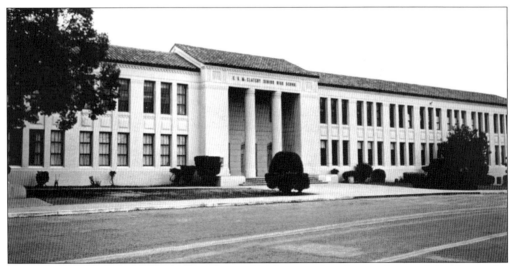

McClatchy High School was designed in 1936 by noted architect Leonard Starks in the classicized Moderne style. Built at a cost of about $800,000 and funded by President Frank D. Roosevelt's Public Works Administration projects, the school was named for editor C.K. McClatchy, of the *Sacramento Bee* publishing family. (Courtesy of McClatchy High Library.)

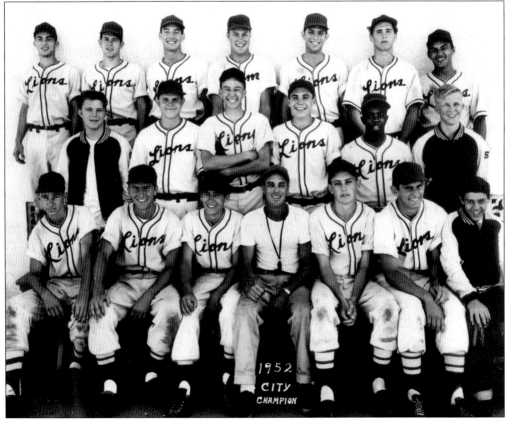

In this 1952 photo, a very happy McClatchy High Lions team has just won the citywide baseball championship. (Courtesy of the Gianulias family.)

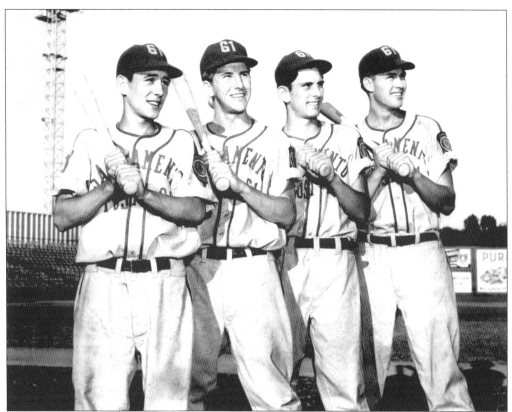

These four high school baseball players were members of the team that won the American Legion Baseball Championship in 1953. Pictured at Edmonds Field, from left to right, are Mac McKenzie, Bill Werry, Gus Gianulias, and Gene Hursch. (Courtesy of the Gianulias family.)

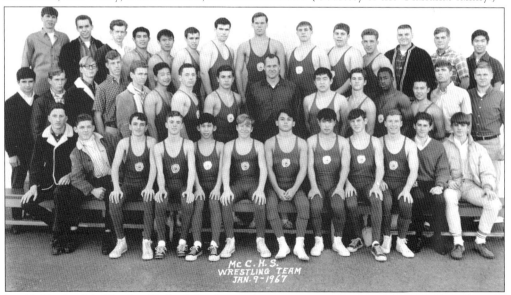

In 1967, the McClatchy High School wrestling team was a group to be reckoned with. (Courtesy of Alan O'Connor.)

Future Supreme Court Justice Anthony Kennedy was already a high achiever in high school at McClatchy, as this page from the 1954 yearbook shows. (Courtesy of McClatchy High Library.)

Author Joan Didion, Anne Holland, and Jennie Lee Clifton work on the McClatchy High *Prospector* in this photo from the 1952 McClatchy yearbook. Joan Didion went on to graduate from Berkeley, worked for *Vogue* in New York, and has been a novelist, essayist, and screenwriter. "We forget all too soon the things we thought we could never forget," she has said. (Courtesy of Special Collections of the Sacramento Public Library)

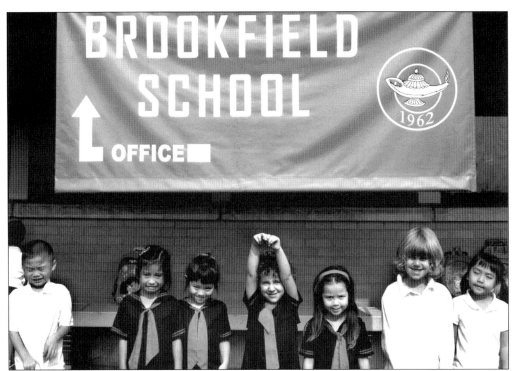

Since 1962, the Brookfield School has been a private, academic elementary school on the edge of William Land Park. These children are from the pre-first-grade class of 2004. (Courtesy of the author.)

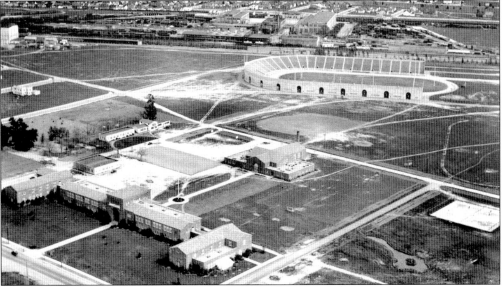

In 1925, the city of Sacramento purchased 60 acres on Freeport Boulevard, across from William Land Park, to provide a campus for Sacramento City College, which had previously been housed at Sacramento High School. This aerial photo of Sacramento Junior College shows raw, empty land surrounding the still sparse campus, and a soccer field in the center of the school. (Courtesy of SAMCC.)

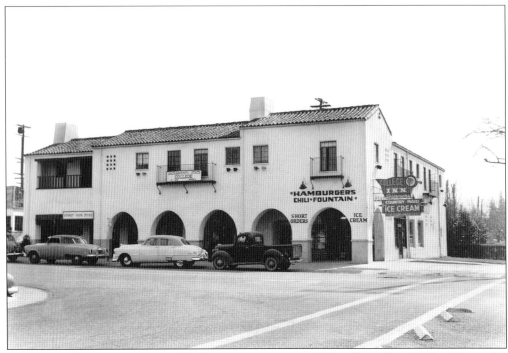

The Eleventh Avenue Annex of the Sacramento Junior College (later City College) housed a restaurant, the college bookstore, and the temporary offices for Sacramento State College, which was later built on J Street in East Sacramento. (Courtesy of UA12:0004. Department of Special Collections and University Archives. The Library. CSUS.)

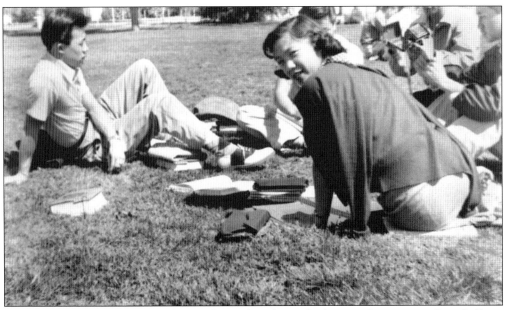

In this 1953 photo, Chinese students relax and study on the lawn at Sacramento City College. (Courtesy of SAMCC.)

Seven

SENATORS AND SOLONS

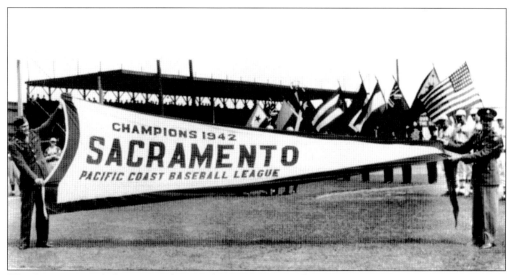

The Sacramento Solons won the Pacific Coast League baseball championship in 1942 during World War II, despite the fact that the team had been thinned out by the war. (Courtesy of Alan O'Connor.)

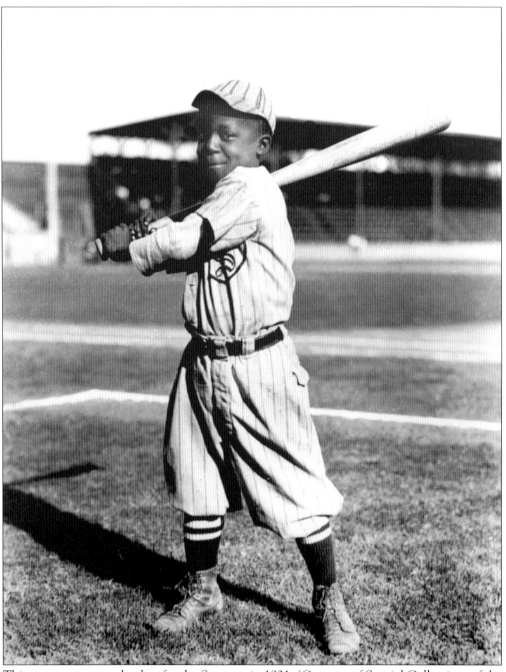

This young man was a bat boy for the Senators in 1921. (Courtesy of Special Collections of the Sacramento Public Library.)

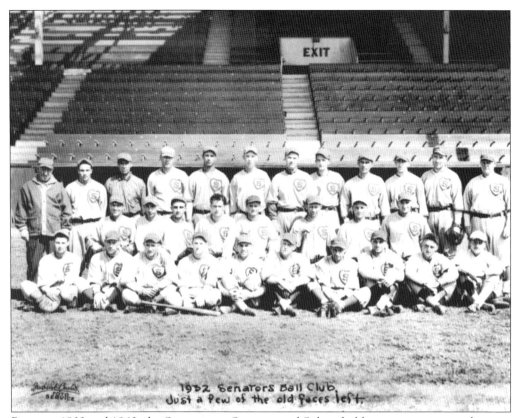

Between 1903 and 1960, the Sacramento Senators and Solons held court at various stadiums at the corner of Riverside and Broadway. Edmonds Field was demolished in 1964, and eventually a Target store and its parking lot were put on the site. This Solons team photo is from 1932. (Courtesy of Alan O'Connor.)

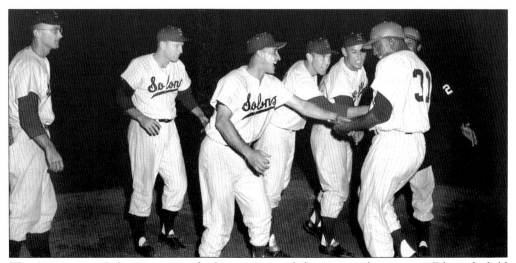

The Sacramento Solons were caught horsing around during a night game at Edmonds field against the Vancouver Mounties in 1958. (Courtesy of SAMCC.)

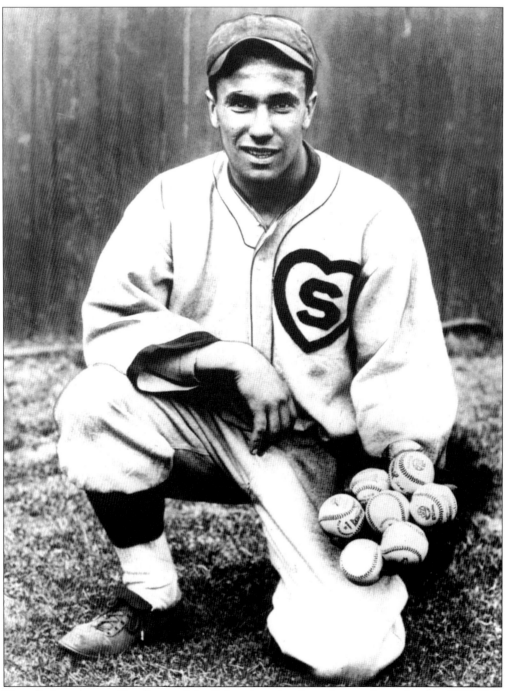

Tony Freitas was considered one of the Solons longtime best players, shown here in 1932. He's showing off his ability to hold seven baseballs in one hand. His huge hands were considered one of the reasons for his baseball prowess. (Courtesy of Alan O'Connor.)

Joe Marty, a Sacramento native, went to Christian Brothers School, where a field is still named after him. He went up to the big leagues—Chicago Cubs—in 1937. He was the first Sacramentan to hit a homerun in the World Series. After serving in World War II, he played for the Solons from 1946 to 1952. (Courtesy of Alan O'Connor.)

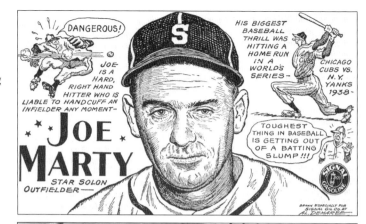

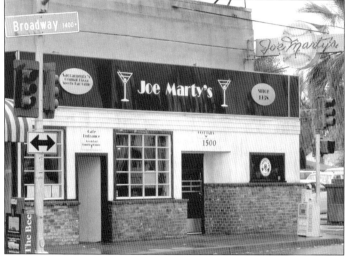

Joe Marty's place is still an institution on Broadway, although Edmond's Field is long gone. (Courtesy of the author.)

This ad ran in the Solons score book each game. (Courtesy of Alan O'Connor.)

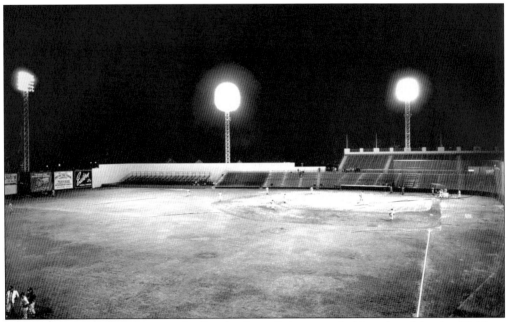

The first night baseball game in the Pacific Coast League was held at then Moering Field on June 10, 1930, between the Sacramento Senators and the Oakland Oaks. (Courtesy of Special Collections of the Sacramento Public Library.)

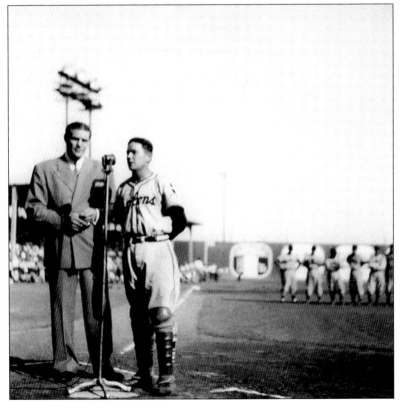

Pictured at Edmonds Field in this 1942 photo are Buddy Baer and Ray Mueller. The Baer brothers—Buddy and champion boxer Max—were well-liked around Land Park. As boys, they rode around on a tandem bike, and impressed neighbors with their size and strength. (Courtesy of Alan O'Connor.)

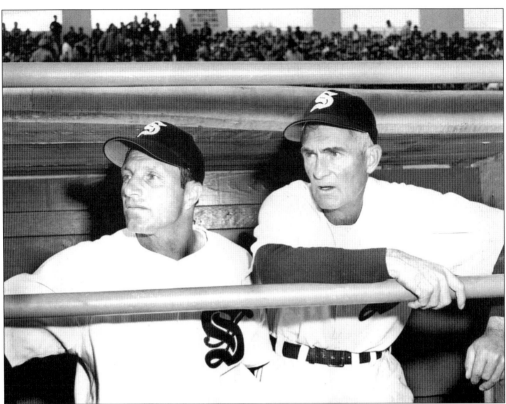

Coach Dolph Camilli and manager Del Baker view a game at Edmonds Field. Dolph Camilli played for the Senators in the 1920s and returned as a coach for the Solons in the 1950s. In 1941, as a player for the Brooklyn Dodgers, he was the 1941 National League MVP. (Courtesy of Alan O'Connor.)

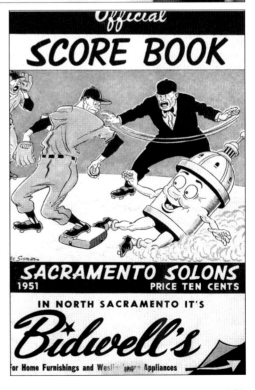

Fans could keep track of the game with this scorebook offered for 10¢. The Solons' mascot was a cheery capitol dome that could always be counted on to be safe at home plate, as drawn here by cartoonist Lee Susman. (Courtesy of Alan O'Connor.)

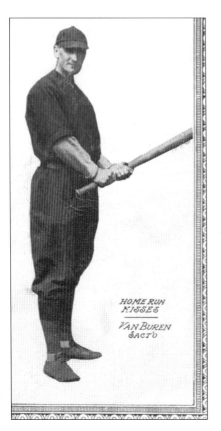

The Solons and Senators were marketed in several series of baseball cards, including this 1912 "Home Run Kisses" card of outfielder Deacon Van Buren. Van Buren played for various Sacramento teams from the late 1890s to 1914. He was a longtime solid outfielder. (Courtesy of Alan O'Conner.)

This ballpark was on the corner of Riverside and Y or Broadway since 1911, when Buffalo Brewery owner Edward Kripp developed a garbage dump into a thriving venue for his beer—and baseball. Here is the entrance to the stadium, beyond the gravestones of the cemetery, with the Tower Theatre in the distance. (Courtesy of SAMCC.)

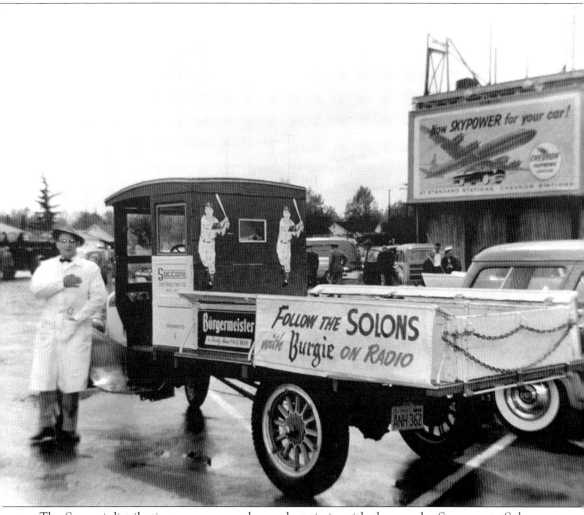

The Saccani distributing company used a product tie-in with the popular Sacramento Solons to promote their Burgermeister beer—also known as Burgie. (Courtesy of Gary Saccani.)

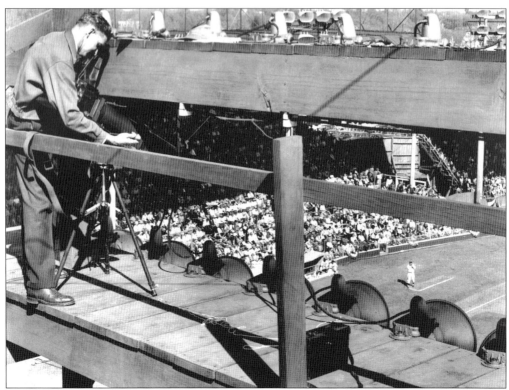

This shot of a photographer taking a picture of a Solons game at Edmonds field was taken in May 1948, three months before the wooden ballpark burned to the ground. (Courtesy of SAMCC.)

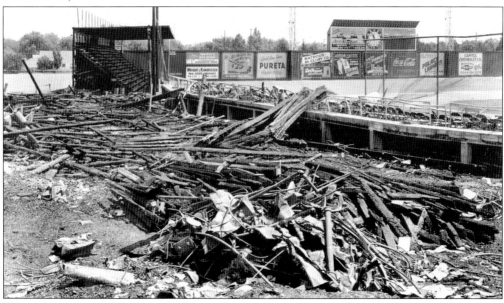

The mostly wooden Edmonds Field burned to the ground after a fan's careless cigarette toss on a hot summer day in July 1948. The field was rebuilt in fireproof, but uncomfortable, concrete. (Courtesy of Special Collections of the Sacramento Public Library.)

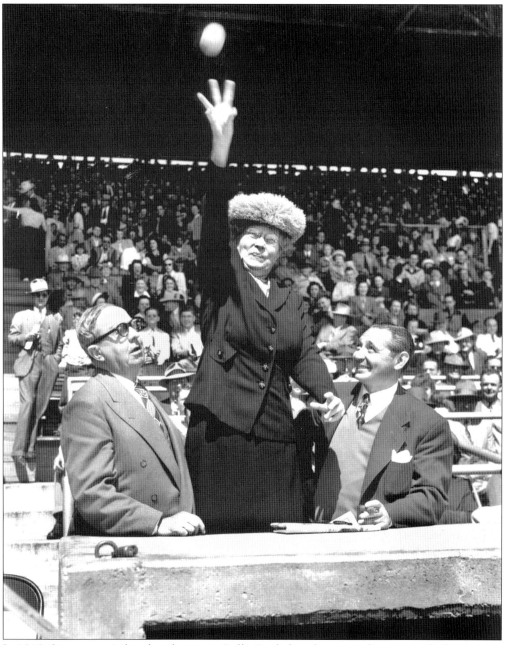

In 1948, Sacramento's first female mayor, Belle Cooledge, threw out the opening ball in a game at the newly reconstructed Edmonds Field. Before becoming mayor, she had a 31-year-long career as a teacher, dean, and vice president at Sacramento Junior College, now City College. Cooledge received a degree in chemistry from UC Davis in 1904. A true individual and even somewhat of a novelty, Cooledge was known for answering her own mail and showing up daily at city hall (although the job was only part-time in those days). (Courtesy of Special Collections of the Sacramento Public Library.)

Charley Schanz was a Sacramento native who went to Christian Brothers School. He pitched for the big leagues, primarily for the Philadelphia Phillies in the 1940s, then was a starting pitcher for the 1952 PCL Seattle Rainers, who won the championship that year. He finished his career with the 1953 Solons. Two of his three sons still live in Land Park. (Courtesy of Alan O'Connor.)

Bob Roselli, shown here at Edmonds Field, was a Solons catcher in the late 1950s. (Courtesy of Alan O'Connor.)

Edmonds Field was home to the Solons, and during the off-season it hosted roller derbies, car races, and high school games. In this photo, the roller derby rink is set up over the field. (Courtesy of Alan O'Connor.)

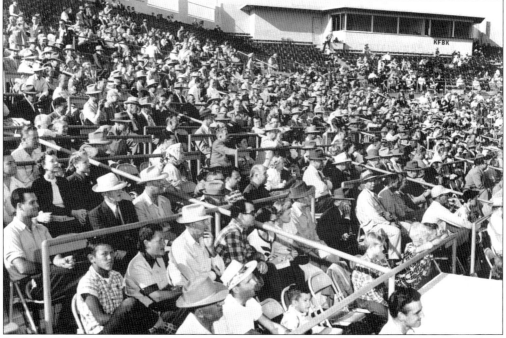

In this 1950 photo, a crowd enjoys a Solons game at Edmonds Field. The games were broadcast by KFBK, as seen on the broadcast box in the upper right corner. (Courtesy of Alan O'Connor.)

Pepper Martin was an outfielder for the St. Louis Cardinals in the 1930s. He managed the Sacramento Solons in 1941 and 1942, and was instrumental in guiding them to the 1942 Pacific Coast League Championship. (Courtesy of Alan O'Connor.)

This Solons outfielder appears overwhelmed by the huge signs lining the back wall. (Courtesy of Alan O'Connor.)

Eight

BROADWAY, TOWER THEATRE, AND TOWER RECORDS

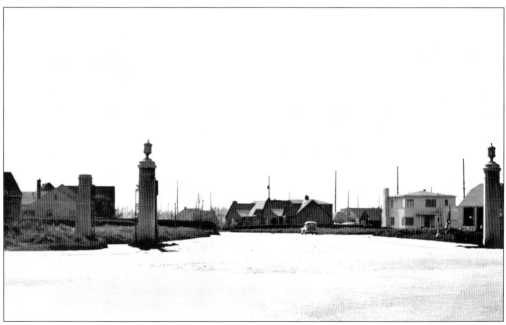

This view of the entrance to Land Park at Broadway and Land Park Drive was taken in 1930. The Tower Theatre would not be built for seven years. The imposing columns and ornate lanterns have long since disappeared. (Courtesy of Joe Genshlea.)

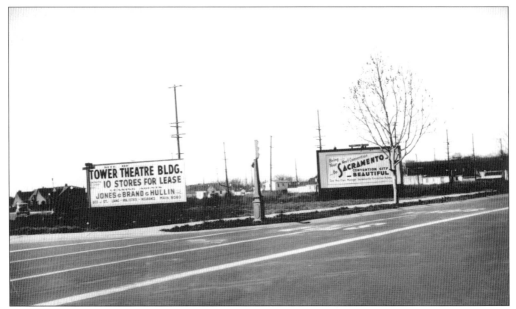

The corner of Land Park Drive and Y is pictured here when it was just an empty lot waiting to be developed. In years past, Y Street was the edge of Sacramento city proper, on top of a levee protecting Sacramento from winter flooding. (Courtesy of SAMCC.)

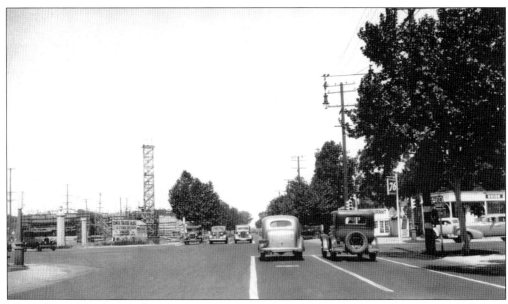

This photo from 1937 shows construction of the Tower Theatre just getting underway. (Courtesy of SAMCC.)

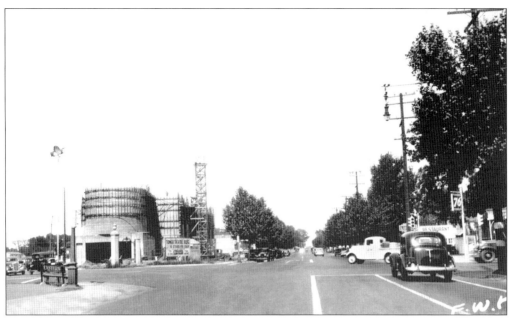

Before the Tower, the corner of Y Street and Land Park was a sleepy intersection bordering the new subdivision of Land Park. Where did all the trees go? (Courtesy of SAMCC.)

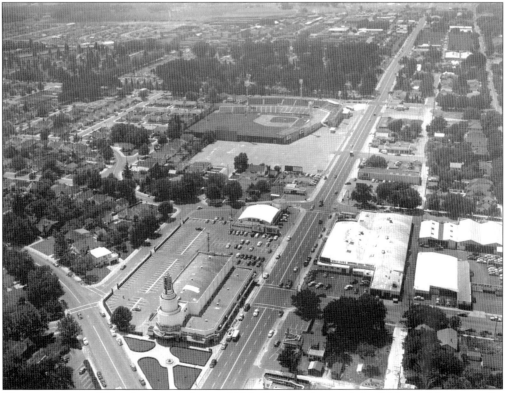

This aerial view of Broadway was taken in 1939, showing the newly built Tower Theatre at the bottom and Edmonds Field and the city cemetery at the top. (Courtesy of SAMCC.)

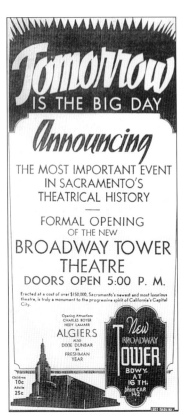

Built in 1938 by theatre promoter Joe Blumenfield, the Tower Theatre has been in continuous operation ever since it opened, and today shows first-run foreign and art films. The first movie shown was *Algiers*, starring Charles Boyer and Hedy Lamarr. Tickets were 25¢ for adults and 10¢ for children. The City of Sacramento renamed Y Street "Broadway" after the Tower was built, hoping to encourage the growth of an entertainment district rivaling that of New York. (Courtesy of Matias Bombal.)

In 1946, the theatre had only one screen. There was a drugstore on the corner of Sixteenth and Broadway, and Zamm's sold caramel corn and homemade candies on the other corner. (Courtesy of Special Collections of the Sacramento Public Library.)

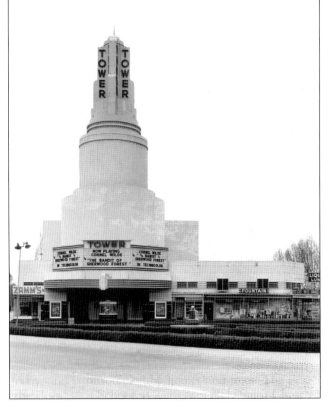

Russ Solomon started selling records in a corner of his father's drugstore in the Tower Building in the 1950s, expanded that to his own store on Broadway in the 1960s, and from there to a worldwide entertainment empire. This 1960 photo shows Tower's first real retail store on Broadway. The art deco sign of the dancing kids still sits on the Tower Theatre Building.)

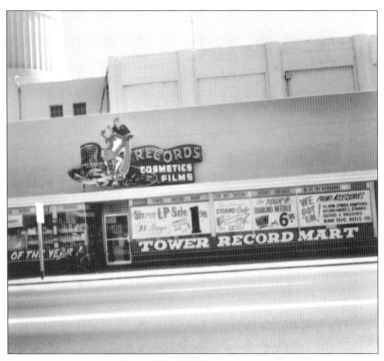

Russ Solomon created Tower Records to feed souls hungering for music. His stores became meccas for music-worshippers of all kinds—pop, classical, jazz— who appreciated Tower's innovative and learned approach to retail music. Rod McKuen wrote a poem for Russ Solomon, describing Tower patrons as "friendly robots in designer jeans and ties too narrow to be tied just right. . . . [They] have heard mind-bending music. Each has seen the Tower beacon light that draws them forward." Solomon is also known for his fashion statement on stuffy business uniforms; he regularly clips the ties of visiting relatives to his office, and he mounts them like trophies on his walls. (Courtesy of Russ Solomon.)

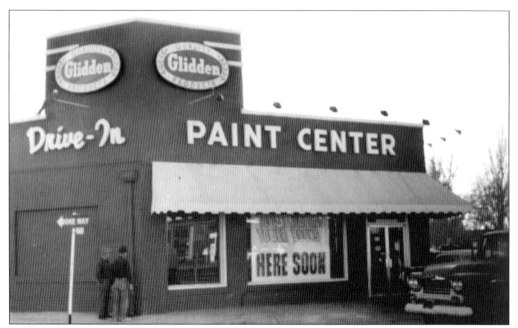

The Glidden Drive-In Paint Center at the corner of Sixteenth and Broadway, shown here n 1964, became the Broadway Tower Record & Books store in 1965. (Courtesy of Russ Solomon.)

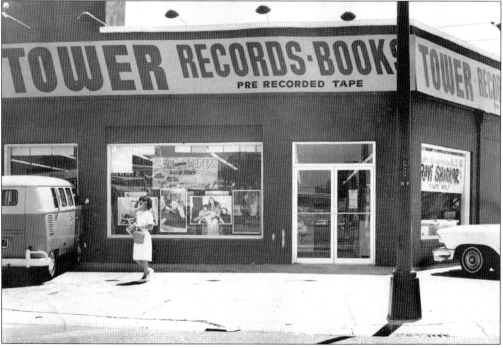

In this c. 1960s photo of the store at Sixteenth and Broadway, eight-track cartridge tapes are advertised in the window, along with tickets for a Ravi Shankar concert. (Courtesy of Russ Solomon.)

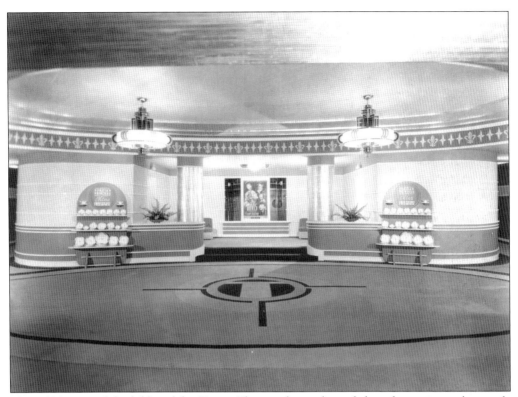

This 1939 view of the lobby of the Tower Theatre shows the stylish and escapist opulence of the movies in those days. Bette Davis was playing in Dark Victory, and "beautiful Persian Princess" china was "Free to the Ladies Every Wed. Eve." (Courtesy of Russ Solomon.)

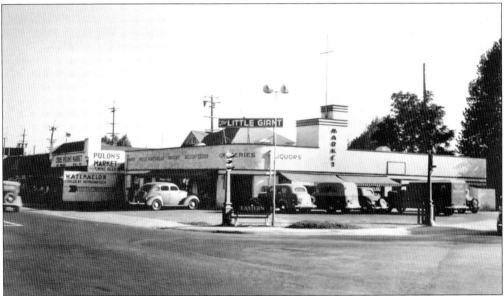

The Little Giant supermarket anchored the corner of Broadway near Land Park, where Tower Records, Books, and Video are now located. This store was also called the Market Basket at one time. (Courtesy of the Gianulias family.)

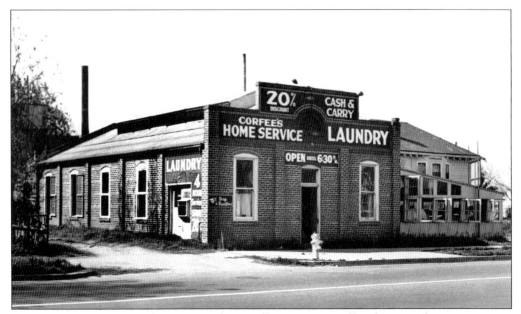

This building on Sixteenth near Broadway still exists as a coffee shop. In the past it was a laundry. You could throw your bundle of dirty laundry down the chute on the left hand side of the building and pick it up four hours later. (Courtesy of Joe Genshlea.)

Next to Edmonds Field on Broadway, roughly where the Target store now sits, was once the setting for huge religious revival tent. A banner read, "Great Spiritual Awakening." (Courtesy of SAMCC.)

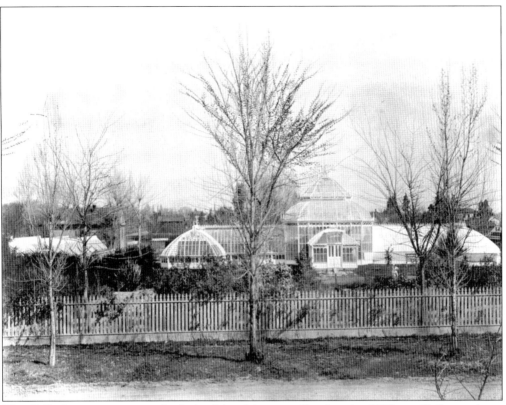

The Bell Conservatory was built by Mrs. Margaret Crocker in 1878 on Y Street (now Broadway), to provide flowers for the old city cemetery across the street. Built from spectacular Belgian colored glass ordered from Tiffany's in New York, the Bell was a Victorian showpiece from the same era as the Conservatory of Flowers in San Francisco's Golden Gate Park. (Courtesy of SAMCC.)

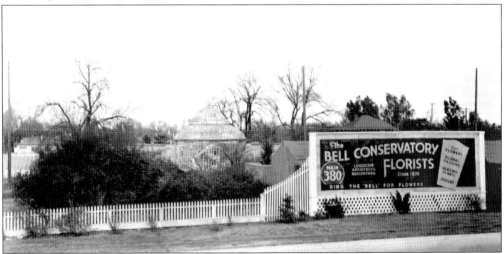

This 1941 photo shows the glass house gradually falling into disrepair. The Bell Conservatory was torn down in 1953 to make way for a Safeway store. The site later became a parking lot. (Courtesy of SAMCC.)

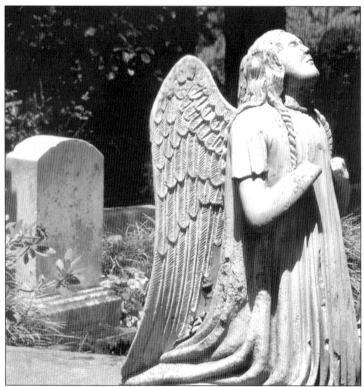

Maria Rupp was a "young and good looking female who kept a drinking saloon" on downtown's K Street during the 1850s. In 1857, while playing the pianoforte for guests, she was murdered by an obsessed suitor. This angel adorns her grave. Others buried in the old city cemetery at Broadway and Riverside include railroad tycoon Mark Hopkins and John Sutter Jr., the son of New Helvetia pioneer John Sutter, who founded Sutter's Fort. (Courtesy of Sacramento Old City Cemetery.)

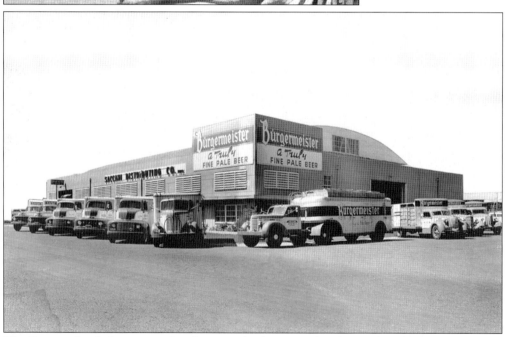

The Saccani family have owned and operated a beverage distribution business in Sacramento since about 1930. The current warehouse is on Fifth Street in West Land Park. Pictured is the Saccani factory in the 1930s or 1940s. Note that the trucks are parked in front of the factory and street corners don't seem to exist. (Courtesy of Gary Saccani.)

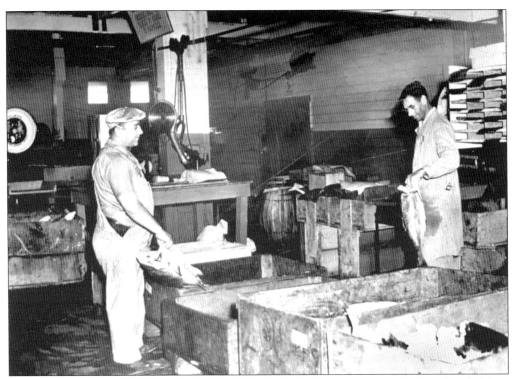

Enio Saccani worked at the Meredith Fish Company on Fifth Street in west Land Park. He is pictured on the left with an unidentified coworker. Enio's older brother, Al, began the Saccani beverage distribution company from an office in the Meredith Fish Company. Later, Al moved Saccani Distributing to downtown Sacramento, and finally to a warehouse on Fifth Avenue. (Courtesy of Gary Saccani.)

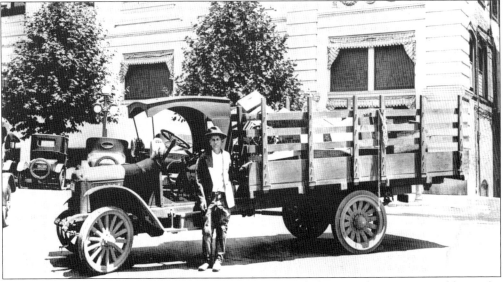

Mr. Lin Lim was one of many Chinese and Japanese truck farmers who grew vegetables in the area south of Sacramento City to sell downtown. Mr. Lin later owned a great deal of property along Y Street/Broadway. (Courtesy of SAMCC.)

Here is a 1930s view of the Western Pacific crossing at Broadway between Nineteenth (Freeport Boulevard) and Twentieth Streets (Courtesy of SAMCC.)

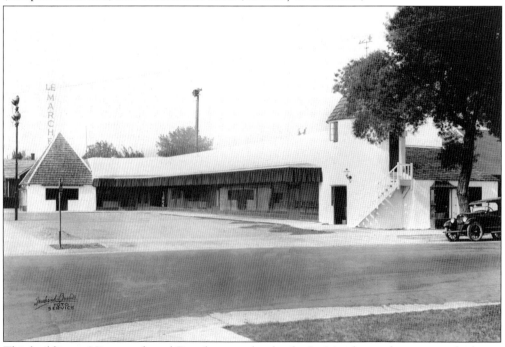

This building at Nineteenth and Broadway used to be the Le Marche produce store, which was run by Japanese farmers. Joe Genshlea remembers shopping there with his mother. Just after the internment call, they found the store completely shuttered, a chilling testament to the impact of the war. The building now houses a Vietnamese restaurant. (Courtesy of Joe Genshlea.)

Nine
FREEPORT

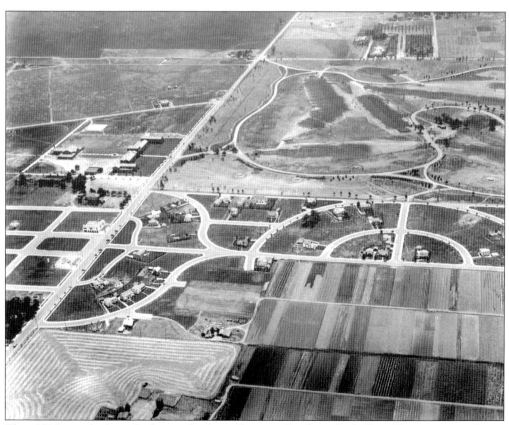

This 1930 aerial photo looks south along Freeport Boulevard. College Tract was just being developed, and was surrounded by fields. Sacramento Junior College (later City College) is at the center left. William Land Park had an entrance at the corner of Freeport and Sutterville, right across from the College Riding Stables. (Courtesy of SAMCC.)

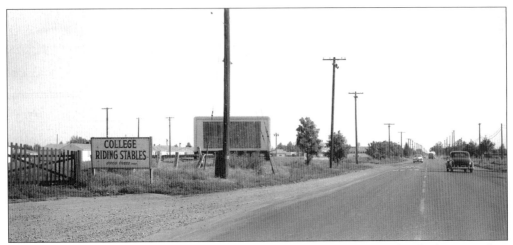

The College Riding Stables were off of Freeport Boulevard, just south of what was then Sacramento Junior College, about at the spot where Sutterville and Freeport now meet. Enthusiasts could rent horses to ride in the new William Land Park. (Courtesy of SAMCC.)

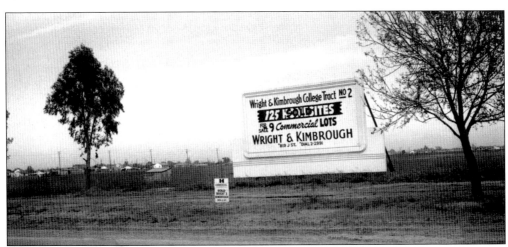

College Tract helped change the sleepy, agricultural land south of the city into a desirable neighborhood. This photo was most likely taken in the early 1930s, and looks west from Freeport Boulevard. (Courtesy of SAMCC.)

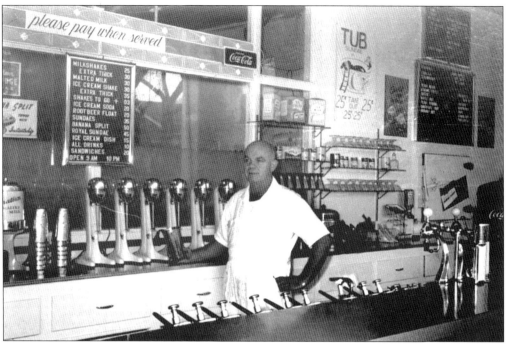

Owner Wert Irwin served up fountain treats at Shasta Ice Cream on Freeport Boulevard. (Courtesy of Julie DiLoreto.)

Shasta Ice Cream was a popular soda fountain on Freeport, which was then known as Twenty-first. (Courtesy of Julie DiLoreto.)

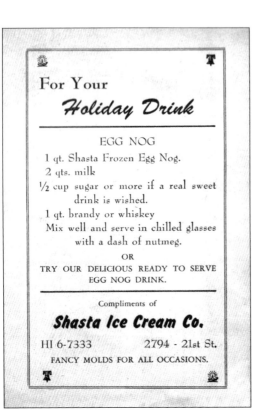

Shasta Ice Cream had a good recipe for eggnog that included a healthy amount of whisky. (Courtesy of Julie DiLoreto.)

Shasta's Ice Cream

Ice Cream	10c
Sherbet (Dish)	10c

Sundaes

Topped With Cream

Strawberry	30c	Pineapple	30c
Black & White	30c	Fudge Sundae Hot	30c
Strawberry & Pineapple	30c	Marshmalow	25c
Chocolate	30c		
With Nuts			

Special Sundaes

Royal Sundae (3 scoops)	40c	Hot Fudge Nut Sundae	35c

Drinks — Fruit Juices

Milk	10c	Shasta Milk Shake	25c
Ice Cream Soda	20c	Shasta Malted Milk	30c
Chocolate Milk	10c	Root Beer Float	20c
Hot Chocolate	15c	Coca Cola	10c
Tea (Hot or Cold)	10c	Grape Fruit Juice	10c & 20c
Coffee	05c	Tomato Juice	10c & 20c

Packaged Ice Cream

Brick	50c	Quart
Cream Pac	40c	Quart
Handipped	75c	Quart

A hot fudge sundae at Shasta sold for 30¢. (Courtesy of Julie DiLoreto.)

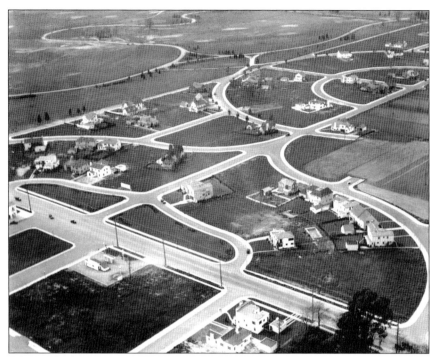

This aerial view looks west across College Tract. Freeport Boulevard is in the foreground, with Eleventh Avenue running diagonally from left to right. The sparse acres of Land Park stretch across the upper left. Only a few houses were built at the time of this c. 1931 photo, and crop fields can still be seen. (Courtesy of SAMCC.)

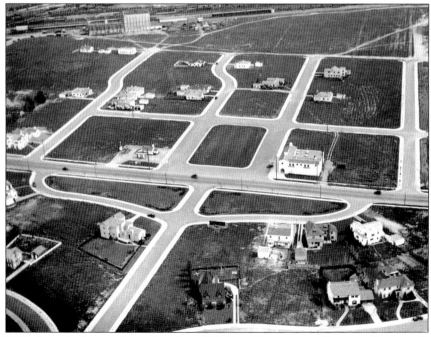

This c. 1931 photo looks east from the edge of College Tract, across Freeport Boulevard toward the old Western Pacific shops on the upper left. (Courtesy of SAMCC.)

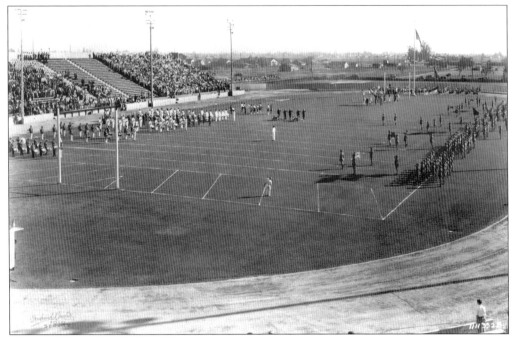

Hughes Stadium at Sacramento City College used to be open at one end, and was used for community and sporting events. This view looks south toward Sutterville Road. (Courtesy of Special Collections of the Sacramento Public Library.)

This 1928 photo captures a photographer with an antique camera in the middle of Hughes Stadium at Sacramento Junior College. (Courtesy of SAMCC.)

Japanese-American children celebrate spring with a maypole dance in Hughes Stadium in this late-1930s photo. (Courtesy of SAMCC.)

This February 27, 1940 photo shows a flooded Sutterville Road, looking east from the WP over-crossing near Sacramento Junior College. A total of 5.56 inches fell in two days, causing massive flooding throughout Land Park and Sacramento. (Courtesy of SAMCC.)

Sacramento Junior College's Hughes Stadium used to host many community events. In this 1938 photo, dancers celebrate the start of spring as part of the May festival. (Courtesy of SAMCC.)